The Artist's Painting

PORTRAIT DRAWING

BY WENDON BLAKE/DRAWINGS BY JOHN LAWN

WATSON-GUPTILL PUBLICATIONS/NEW YORK

Copyright © 1981 by Billboard Ltd.

Published in 1981 in the United States by Watson-Guptill Publications,
a division of VNU Business Media, Inc.,
770 Broadway, New York, NY 10003
www.wgpub.com

Library of Congress Cataloging in Publication Data

Blake, Wendon.
 Portrait drawing.

 (The artist's painting library)
 Originally published as pt. 3 of the author's
The drawing book.
 1. Portrait drawing—Technique. I. Lawn, John.
II. Blake, Wendon. Drawing book. III. Title.
IV. Series: Blake, Wendon. Artist's painting library.
NC773.B57 1981 743'.42 81-11533
ISBN 0-8230-4094-1 AACR2

Manufactured in U.S.A.

First Printing, 1981

19 20 / 05

CONTENTS

Portrait Drawing. The human face is so endlessly fascinating, so infinitely diverse, so expressive of the most delicate emotional nuances that many artists have devoted their lives to portraiture. Every sitter is different, presenting a new and fascinating challenge to the artist who must capture not only the form and detail of the sitter's face, but also the unique flavor of the sitter's personality. The same face can change radically with a slight turn of the head or a slight difference in the direction of the light. And as the sitter's mood changes, the emotional content of the portrait changes too. Thus, the expressive possibilities of portraiture are so great that drawing the human head can become an obsession—one of life's most delightful obsessions—and you may find this subject so absorbing that other subjects seem tame. Like so many artists throughout the centuries, you may discover that there's nothing more exciting than watching a real human being come to life on paper. For the artist who's fascinated by people, the human face is the ultimate subject.

Form and Proportion. In the drawings of the great Renaissance masters, the complex form of the human head is often visualized very simply—as an egg shape with guidelines that wrap around the egg to define the placement of the features. In the first few pages of *Portrait Drawing,* you'll learn how to put this elementary diagram of the head to work. You'll learn to draw the egg shape in line and then make it three-dimensional by adding light and shade. You'll learn how to convert that "Renaissance egg" into a variety of male and female heads, seen from various angles: front view, side view, three-quarter view, and finally, a view of the head tilted downward. It's important to memorize this egg shape—and the placement of its guidelines—so that you can then adapt it, with subtle changes in proportion, to any head you may draw.

Drawing the Features. One of the best ways to learn to draw is to look over the shoulder of a skilled professional as he draws, then try it yourself. You'll watch noted artist John Lawn draw each facial feature, step by step, from a variety of angles. You'll see him draw male and female eyes—front, three-quarter, and side views, as well as tilted downward. In the same way, you'll learn to draw the male and female nose and mouth as seen in these same four views. And finally, you'll learn how to draw the ear as seen from the front and side of the head.

Drawing the Complete Head. Having mastered the basic form of the head and learned how to draw the fea-

tures, you'll then watch John Lawn put all this information together into demonstration drawings of complete male and female heads. You'll watch him build the overall form of the head and the forms of the individual features, from the first sketchy guidelines to the final drawing, fully realized in light and shade. The step-by-step demonstrations of the features and the complete head all show four fundamental stages in executing a successful drawing: blocking in the forms with simple guidelines; refining the contours; blocking in the tones in broad masses; and completing the drawing by refining the lines and tones and then adding the last touches of detail.

Complete Portrait Demonstrations. After demonstrating the fundamentals, Lawn goes on to demonstrate, step by step, how to draw ten complete portraits of different types of sitters, including various hair and skin tones, ages, racial and ethnic types. The demonstrations also show how to render diverse lighting effects that accentuate the character, beauty, and expressiveness of the individual head. The demonstrations are grouped according to drawing medium. There are pencil drawings of a blond woman, a brown-haired man, a black man, and a dark-haired woman. Chalk drawings include a dark-haired man, a blond man, and an oriental woman. Finally, there are charcoal drawings of a brown-haired woman, a black woman, and a gray-haired man. Each of these step-by-step demonstrations shows every drawing operation, from the first stroke on the paper to the last. The demonstration section concludes with a brief review of four different types of lighting that are particularly effective in drawing portraits; each type is illustrated with a drawing that explains how the specific method of lighting affects the character of the head.

Drawing Media. Each step-by-step portrait demonstration presents a different method of rendering form, texture, and light and shade in pencil, chalk, and charcoal. You'll see how form is rendered entirely with lines and strokes; how tone can be created by blending, so that pencil, chalk, and charcoal handle like paint; and finally, how lines, strokes, and blending can be combined. The demonstrations are executed on a variety of drawing papers to show you how the drawing surface influences the tone and texture of the portrait. These various techniques, drawing tools, and papers are dramatically illustrated by close-ups of sections of finished drawings, reproduced actual size.

Keep It Simple. The best way to start drawing is to get yourself just two things: a pencil and a pad of white drawing paper about twice the size of the page you're now reading. An ordinary office pencil will do—but test it to make sure that you can make a pale gray line by gliding it lightly over the paper, and a rich black line by pressing a bit harder. If you'd like to buy something at the art-supply store, ask for an HB pencil, which is a good all-purpose drawing tool, plus a thicker, darker pencil for bolder work, usually marked 4B, 5B, or 6B. Your drawing pad should contain sturdy white paper with a very slight texture—not as smooth as typing paper. (Ask for cartridge paper in Britain.) To get started with chalk drawing, all you need is a black pastel pencil or a Conté pencil. And just two charcoal pencils will give you a good taste of charcoal drawing: get one marked "medium" and another marked "soft." You can use all these different types of pencils on the same drawing pad.

Pencils. When we talk about pencil drawing, we usually mean *graphite* pencil. This is usually a cylindrical stick of black, slightly slippery graphite surrounded by a thicker cylinder of wood. Artists' pencils are divided roughly into two groupings: soft and hard. A soft pencil will make a darker line than a hard pencil. Soft pencils are usually marked B, plus a number to indicate the degree of softness—3B is softer and blacker than 2B. Hard pencils are marked H and the numbers work the same way—3H is harder and makes a paler line than 2H. HB is considered an all-purpose pencil because it falls midway between hard and soft. Most artists use more soft pencils than hard pencils. When you're ready to experiment with a variety of pencils, buy a full range of soft ones from HB to 6B. You can also buy cylindrical graphite sticks in various thicknesses to fit into metal or plastic holders. And if you'd like to work with broad strokes, you can get rectangular graphite sticks about as long as your index finger.

Chalk. A black pastel pencil or Conté pencil is just a cylindrical stick of black chalk and, like the graphite pencil, it's surrounded by a cylinder of wood. But once you've tried chalk in pencil form, you should also get a rectangular black stick of hard pastel or Conté crayon. You may also want to buy cylindrical sticks of black chalk that fit into metal or plastic holders.

Charcoal. Charcoal pencils usually come in two forms. One form is a thin stick of charcoal surrounded by wood, like a graphite pencil. Another form is a stick of charcoal surrounded by a cylinder of paper that you can peel off in a narrow strip to expose fresh charcoal as the point wears down. When you want a complete "pal-

ette" of charcoal pencils, get just three of them, marked "hard," "medium," and "soft." (Some manufacturers grade charcoal pencils HB through 6B, like graphite pencils; HB is the hardest and 6B is the softest.) You should also buy a few sticks of natural charcoal. You can get charcoal "leads" to fit into metal or plastic holders like those used for graphite and chalk.

Paper. You could easily spend your life doing wonderful drawings on ordinary white drawing paper, but you should try other kinds. Charcoal paper has a delicate, ribbed texture and a very hard surface that makes your stroke look rough and allows you to blend your strokes to create velvety tones. And you should try some *really* rough paper with a ragged, irregular "tooth" that makes your strokes look bold and granular. Ask your art-supply dealer to show you his roughest drawing papers. Buy a few sheets and try them out.

Erasers (Rubbers). For pencil drawing, the usual eraser is soft rubber, generally pink or white, which you can buy in a rectangular shape about the size of your thumb or in the form of a pencil, surrounded by a peel-off paper cylinder like a charcoal pencil. For chalk and charcoal drawing, the best eraser is kneaded rubber (or putty rubber), a gray square of very soft rubber that you can squeeze like clay to make any shape that's convenient. A thick, blocky soap eraser is useful for cleaning up the white areas of the drawing.

Odds and Ends. You also need a wooden drawing board to support your drawing pad—or perhaps a sheet of soft fiberboard to which you can tack loose sheets of paper. Get some single-edge razor blades or a sharp knife (preferably with a safe, retractable blade) for sharpening your drawing tools; a sandpaper pad (like a little book of sandpaper) for shaping your drawing tools; some pushpins or thumbtacks (drawing pins in Britain); a paper cylinder (as thick as your thumb) called a stomp, for blending tones; and a spray can of fixative, which is a very thin, virtually invisible varnish to keep your drawings from smudging.

Work Area. When you sit down to work, make sure that the light comes from your left if you're right-handed, and from your right if you're left-handed, so your hand won't cast a shadow on your drawing paper. A jar is a good place to store pencils, sharpened end up to protect the points. Store sticks of chalk or charcoal in a shallow box or in a plastic silverware tray with convenient compartments—which can be good for storing pencils too. To keep your erasers clean, store them apart from your drawing tools—in a separate little box or in a compartment of that plastic tray.

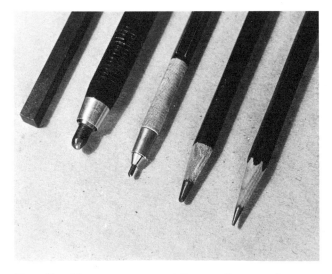

Pencils. The common graphite pencil comes in many forms. Looking from right to left, you see the all-purpose HB pencil; a thicker, softer pencil that makes a broader, blacker mark; a metal holder that grips a slender, cylindrical lead; a plastic holder that grips a thick lead; and finally a rectangular stick of graphite that makes a broad, bold mark on the paper. It's worthwhile to buy some pencils as well as two or three different types of holders to see which ones feel most comfortable in your hand.

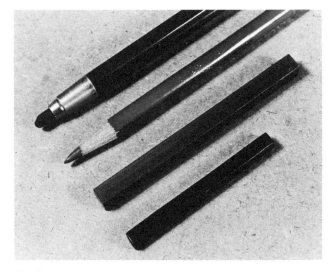

Chalk. Shown here are four kinds of chalk. Looking from the lower right to the upper left, you see the small, rectangular Conté crayon; a larger, rectangular stick of hard pastel; hard pastel in the form of a pencil that's convenient for linear drawing; and a cylindrical stick of chalk in a metal holder. All these drawing tools are relatively inexpensive, so it's a good idea to try each one to see which you like best.

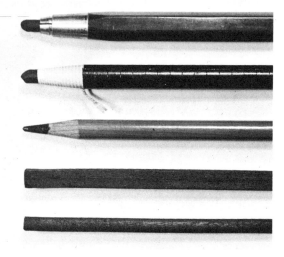

Charcoal. This versatile drawing medium comes in many forms. Looking up from the bottom of this photo, you see a cylindrical stick of natural charcoal; a rectangular stick of the same material; a charcoal pencil; another charcoal pencil—with paper that you gradually tear away as you wear down the point; and a cylindrical stick of charcoal in a metal holder. Natural charcoal smudges and erases easily, and so it's good for broad tonal effects. A charcoal pencil will make firm lines and strokes, but the strokes don't blend as easily.

Erasers (Rubbers). From left to right, you see the common soap eraser, best for cleaning broad areas of bare paper; a harder, pink eraser in pencil form for making precise corrections in small areas of graphite-pencil drawings; a bigger pink eraser with wedge-shaped ends for making broader corrections; and a square of kneaded rubber (putty rubber) that's best for chalk and charcoal drawing. Kneaded rubber squashes like clay (as you see in the upper right) and can take any shape you want. Press the kneaded rubber down on the paper and pull away; scrub only when necessary.

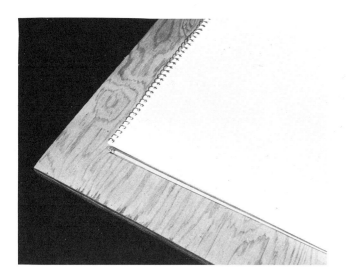

Drawing Board and Pad. Drawing paper generally comes in pads that are bound on one edge like a book. Most convenient is a spiral binding like the one you see here, since each page folds behind the others when you've finished a drawing. The pad won't be stiff enough to give you proper support by itself, so get a wooden drawing board from your art-supply store—or buy a piece of plywood or fiberboard. If you buy your drawing paper in sheets, rather than pads, buy a piece of soft fiberboard to which you can tack your paper.

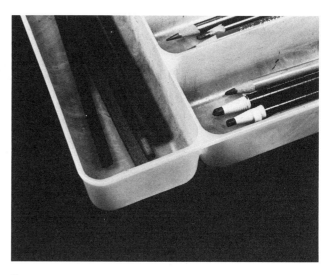

Storage. Store your pencils, sticks of chalk, and sticks of charcoal with care—don't just toss them into a drawer where they'll rattle around and break. The compartments of a silverware container (usually made of plastic) provide good protection and allow you to organize your drawing tools into groups. Or you can simply collect long, shallow cardboard boxes—the kind that small gifts often come in.

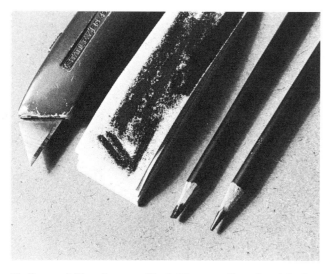

Knife and Sandpaper Pad. The pencil at the right has been shaped to a point with a mechanical pencil sharpener. The other pencil has been shaped to a broader point with a knife and sandpaper. The knife is used to cut away the wood without cutting away much of the lead. Then the pencil point is rubbed on the sandpaper to give it a broad, flat tip. Buy a knife with a retractable blade that's safe to carry. To the right of the knife you see a sandpaper pad that you can buy in most art-supply stores; it's like a small book, bound at one end so you can tear off the graphite-coated pages.

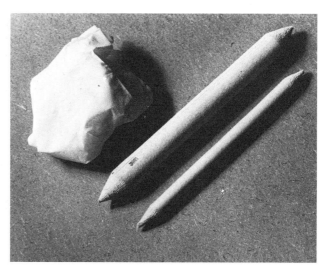

Stomps and Cleansing Tissue. To blend charcoal and push the blended tones into tight corners, you can buy stomps of various sizes in any good art-supply store. A stomp is made of tightly rolled paper with a tapered end and a sharp point. Use the tapered part for blending broad areas and the tip for blending smaller areas. A crumpled cleansing tissue can be used to dust off unsatisfactory areas of a drawing in natural charcoal. (It's harder, however, to dust off the mark of a charcoal pencil.) You can also use the tissue to spread soft tones over large areas.

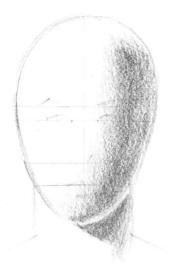

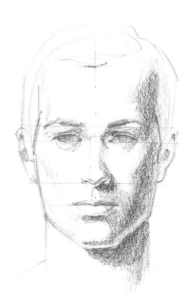

Egg Shape. Seen from the front, the head is shaped like an egg. Many artists actually begin by drawing an egg shape, as you see here. Drawing a vertical center line helps you to place the features symmetrically. It also helps if you draw horizontal guidelines to locate the features on either side of the vertical center line.

Head Shape. The tones on the head follow the same sequence as the tones on the egg. Looking from left to right, you can see four tonal areas that flow smoothly together: light; halftone (or middletone), where the shape begins to curve away from the light; shadow; and reflected light, where the shadow turns paler. The chin casts a shadow on the neck.

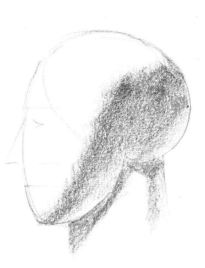

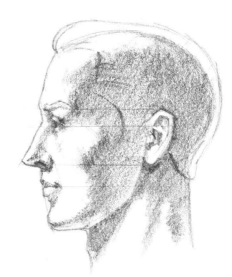

Egg Shapes. When you draw a side view, visualize the head as two overlapping eggs; one vertical and one horizontal, with both tilting a bit. Once again, looking from left to right, you can see the tonal gradations of light, halftone (or middletone), shadow, and reflected light. There's a similar gradation on the right side of the cylindrical neck.

Head Shape. Obviously, the forms of the head are more complex than the egg shape and cylinder, but the gradation of tones is essentially the same. You can see the light, halftone, shadow, and reflected light most clearly on the big shapes of the skull, cheek, and jaw. They also appear in more subtle form on the eye socket, nose, and neck.

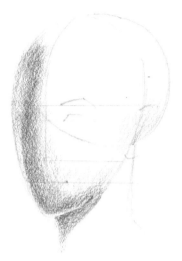

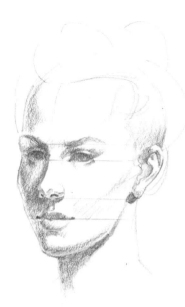

Egg Shapes. The head turns until it's midway between a front and side view. This is called a *three-quarter view*. You still see two overlapping eggs. The vertical egg is obvious, but you see a bit less of the horizontal egg. The gradation of four tones remains essentially the same.

Head Shape. On the egg and on the head, the light comes from the right, and so the gradation of light, halftone, shadow, and reflected light moves from right to left. You can see the gradation most clearly on the shadow side of the face. It's also obvious on the chin and jaw. The nose casts a shadow on the upper lip, while the earlobe casts a shadow behind the jaw.

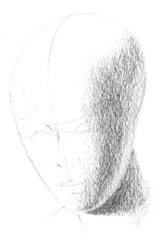

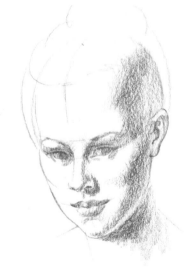

Egg Shapes. When the head tilts downward—or when you're looking at the head from above—you still see the two overlapping egg shapes, but an important change takes place in the guidelines. Note how they curve: the horizontal guidelines wrap around the head in parallel rings. Although the alignment of the features may change, the gradation of four tones remains essentially the same.

Head Shape. Looking from left to right on the egg and on the real head, you can still see the four interlocking tones: light, halftone, shadow, and reflected light, plus the cast shadow on the neck. The gradation is most apparent on the forehead, cheek, and jaw. You can also see it on the eye sockets and nose. The light comes from the upper left, and so the nose casts a shadow to the right.

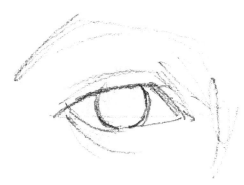

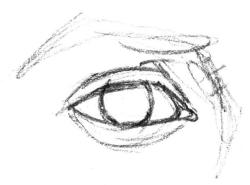

Step 1. The artist begins to draw the eye by indicating its basic contours with a few casual but carefully placed lines. He suggests the complete upper and lower lids, as well as the eyebrow and the corner of the eye socket at the side of the nose. At this stage the iris is just a circle. Study the contours of the inner edges of the lids. Starting from the outer corner, the top lid follows a long, flattened curve and turns down a bit at the inside corner. The lower lid does just the opposite, starting from the inside corner as a long, flattened curve and then turning upward at the outside corner.

Step 2. Pressing harder on the point of his pencil, the artist moves back over the casual guidelines of Step 1 to refine the contours. The rather angular lines of Step 1 become rounder and more rhythmic. They eye begins to look more lifelike. The shapes of the lids are more clearly defined. It's particularly important to remember that the upper lid always overlaps the iris, cutting off part of the circle. The lower lid touches the iris but doesn't overlap it quite so much.

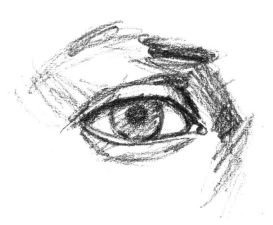

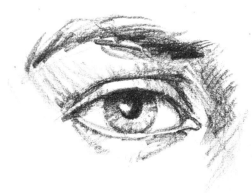

Step 3. Having drawn the contours more accurately, the artist now begins to block in the tones with broad, spontaneous strokes. The tones are actually clusters of parallel strokes, which you can see most clearly in the tone of the iris and the shadow inside the eye socket. The artist suggests the dark spot of the pupil, and he carefully draws the shadow that the upper lid casts across the iris and over the white of the eye. He indicates the shadows at the corners of the lids and on the underside of the lower lid.

Step 4. In the final stage, the artist strengthens his tones and adds the final details. He darkens the shadowy lines around the eyelids and deepens the shadow cast over the eye by the upper lid. He darkens the iris and the pupil, picking out the highlight on the iris with a quick touch of an eraser. More clusters of parallel lines darken the corner of the eye socket alongside the nose. Scribbly, erratic lines suggest the eyebrow. And using the sharp point of a pencil, he carefully retraces the contours of the upper lid and the tear ducts at the corner of the eye.

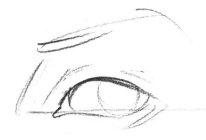

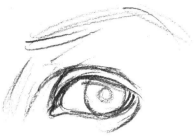

Step 1. When the head turns from a front view to a three-quarter view, the eye turns too, of course, and its shape changes. If the sitter is looking straight at you, the iris moves to the side, as you see here. Once again, the artist begins with quick, casual lines. He draws the main contours of the eyelids, iris, and eyebrow, with a slight suggestion of the eye socket along the side of the nose. Have you noticed the straight, horizontal line that crosses the eye? That's the guideline that the artist has drawn across the egg-shaped head to locate the eyes.

Step 2. The artist goes over the lines of Step 1 with darker, more precise lines. The curves of the eyelids are defined more carefully, the disc shape of the iris is drawn more precisely, and the pupil is added. In the three-quarter view, the eye doesn't seem quite as wide as it does in the front view. But the curving shapes of the lids are essentially the same. From the outer corner, the top lid begins as a long, flattened curve and then turns steeply downward at the inside corner. Conversely, the lower lid starts from the inside corner as a long, flattened curve and then turns sharply upward at the outside corner.

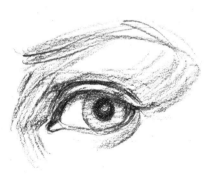

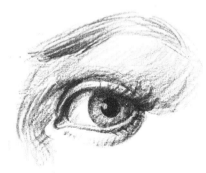

Step 3. The artist begins to suggest the distribution of tones with clusters of parallel strokes. These broad strokes are made with the side of the pencil lead, rather than with the sharp tip. Notice how the strokes tend to curve around the contours of the eye sockets. The shadowy edges of the lids are drawn carefully. Once again, the artist indicates the shadow that's cast across the eye by the upper lid. The pupil is darkened. The eyebrow is darkened slightly, but the strongest darks are saved for the final step.

Step 4. The artist blackens the pupil, darkens the iris, and strengthens the shadowy edges of the eyelids. More groups of parallel strokes—made by the side of the lead—curve around the eye socket to darken the tones and make its shape look rounder. On the white of the eye, a touch of shadow is added at the corner. Long, graceful lines suggest the hairs of the eyebrow, while short, curving lines suggest eyelashes. An eraser picks out highlights on the pupil. Compare the soft, rounded character of this female eye with the more angular male eye on the preceding page.

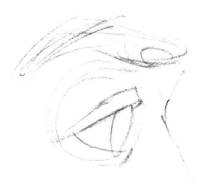

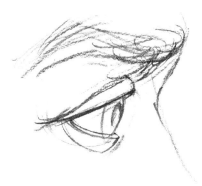

Step 1. The eye is actually a small sphere that rests in the circular cup of the eye socket. It's a good idea to begin by drawing the complete sphere, as the artist does here. Around the sphere, he wraps the eyelids, like two curving bands, and places the iris on the front of the sphere. The eyebrow curves around the edge of the sphere. If you visualize the eye in this way, it looks rounder and more three-dimensional. Later on, you can erase the lines of the sphere, of course.

Step 2. Working with the pencil point, the artist carefully sharpens the lines of the lids, draws the iris more precisely, and adds the pupil. A second line is added to indicate the top of the lower lid. Now you have an even stronger feeling that the eyelids are bands of skin that wrap around the sphere of the eye—although the artist has erased most of the lines of the sphere that appear in Step 1. The artist begins to strengthen the lines of the eyebrow, which has a distinct S-curve. Compare the upper and lower lids: the upper lid has a steeper slant than the lower lid, and juts farther forward.

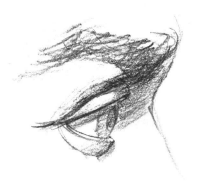

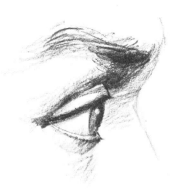

Step 3. Moving the side of the pencil lightly over the paper with parallel strokes, the artist begins to block in the tones. He darkens the eyebrow and indicates the shadow beneath the brow, just above the bridge of the nose. He adds shadows to the edges of the curving eyelids and places a deep shadow in the eye socket, just above the upper lid. The upper lid casts a distinct strip of shadow over the iris and the white of the eye. The artist darkens the iris and the pupil.

Step 4. Still working with the side of the pencil, the artist darkens the shadows with clusters of broad, parallel strokes. He accentuates the shadows around the eye, making the eye sockets seem deeper. He also darkens the shadowy edges of the eyelids and adds a few dark touches to suggest eyelashes. The iris becomes a darker tone and the pupil becomes darker still—highlighted with a white dot made by the tip of a kneaded rubber eraser. Just above the lower lid, a hint of tone makes the white of the eye look rounder. Rhythmic, curving strokes complete the eybrow.

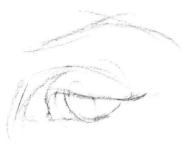

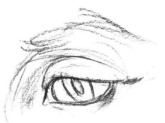

Step 1. When the head tilts downward, the eye tilts downward too. As you can observe in this preliminary sketch, the tilted view of the eye shows you more of the upper lid and less of the lower lid. You also see less of the iris and the white of the eye because the upper lid seems to come farther down. These first sketchy lines define the curves of the eyelids—wrapping around the ball of the eye—as well as the corner of the eye socket and the typical S-curve of the eyebrow.

Step 2. The artist draws the contours of the eye and the eyelids carefully over the sketchy guidelines of Step 1. Because we're looking down at the eye from above, we see a lot of the upper lid, and the shape of the eye itself seems more slender than it looks in a front view. The artist sharpens the lines of the iris and draws the pupil. He draws the tear duct more precisely. Then he begins to suggest the inner contours of the eye socket with groups of curving lines that follow the rounded shape of the socket. Note how the upper lid overlaps the lower lid at the outer corner.

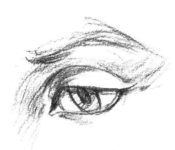

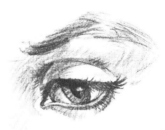

Step 3. To block in the tones, the artist moves the side of the pencil lightly across the paper. Clusters of curving, parallel strokes suggest the roundness of the eye socket, above the eye and in the corner adjacent to the nose. The shadows on the lids are also executed with curving strokes. The iris is darkened with parallel strokes, and the artist presses harder on the pencil to darken the pupil. Horizontal strokes suggest the shadow cast by the upper lid across the iris and the white of the eye. A deep shadow is placed in the inner corner of the eye. Long, curving, rhythmic strokes suggest the eyebrow.

Step 4. To complete the drawing, the artist builds up the shadow around the eye with thick strokes, using the side of the pencil lead. He strengthens the deep shadow that's cast by the eye socket on the upper lid and then darkens the shadow beneath the lower lid. He darkens the iris and pupil, deepens the shadow that's cast by the upper lid, and adds delicate touches of tone to the white of the eye. Most of the eye is in shadow because it turns downward, away from the light. An eraser picks out just a few areas of light, and the point of the pencil adds the details of the lashes and eyebrow.

Step 1. The artist begins to draw the mouth with straight, simple construction lines. Down the center of the drawing, you can see the vertical center line that helps him construct a symmetrical mouth and chin. The dividing line between the lips is one of the horizontal guidelines that the artist draws across the egg-shaped head. Above this horizontal line, the artist draws four basic lines for the upper lip and three lines for the lower lip, plus a scribble to suggest a shadow beneath the lower lip. Note that he also indicates the groove that travels from the upper lip to the base of the nose.

Step 2. The upper lip is actually shaped something like a pair of wings that meet at the center line of the face. The artist redraws the upper lip with firmer strokes to indicate this shape. The lower lip consists of a blocky frontal plane and two triangular side planes. The artist adds lines to indicate these planes. He also strengthens the vertical center line to suggest the slight crease that runs down the center of the lower lip.

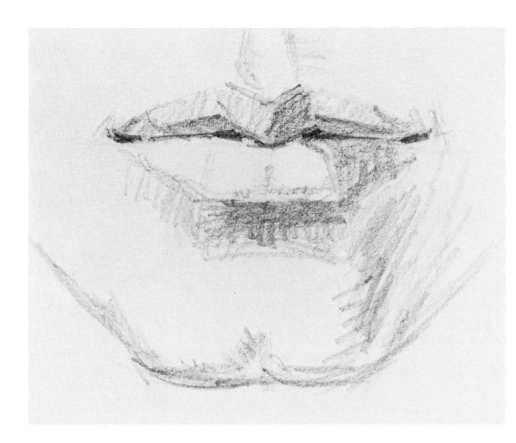

Step 3. Turning the pencil to make broad strokes with the side of the lead, the artist begins to block in the tones with groups of parallel strokes. The upper lip is usually in shadow because it turns downward, away from the light. Between the lips, the artist places a line of deep shadow. And there's a pool of shadow beneath the lower lip. The light is coming from the left, so the artist places shadows on the side planes at the right—away from the light. For the same reason, he begins to indicate a shadow on the right side of the chin and suggests a bit of shadow in the groove above the upper lip.

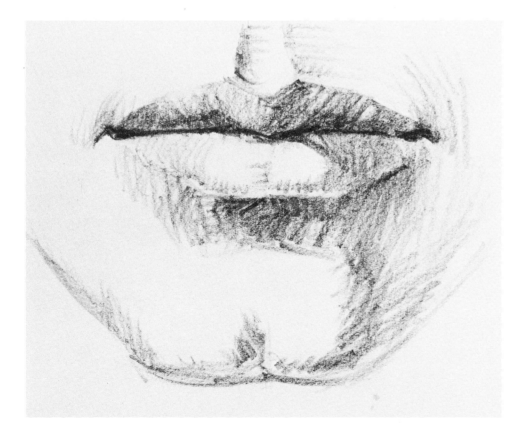

Step 4. Having indicated the pattern of light and shade roughly in Step 3, the artist strengthens all these tones in the final step. He darkens the upper lip, which is just a bit lighter at the left—the lighter side of the face. The lower lip is divided into three tonal areas—halftone at the left, light in the center, and shadow at the right—which correspond to the three planes drawn in Step 2. The artist strengthens the dark line between the lips, builds up the shadow beneath the lower lip, strengthens the modeling on the jaw and chin, and adds more tone to the groove above the upper lip. Notice the strong touches of shadow at the corners of the mouth.

Step 1. The artist draws the wing shape of the upper lip with curving lines to suggest the softness of the female mouth. He draws the full lower lip with a single curve. The horizontal line between the lips is the usual horizontal guideline that he draws across the egg shape of the head to indicate the placement of the mouth. The head turns slightly to the left and so does the mouth; therefore, the vertical center line is also slightly to the left, and the mouth is no longer symmetrical. We see more of its right side.

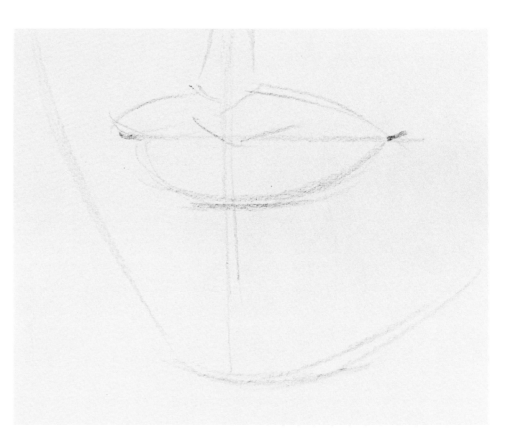

Step 2. Going back over the sketchy lines of Step 1, the artist draws the shapes of the lips more exactly. Study the intricate contours of the wing-shaped upper lip. Note how the center of the upper lip dips downward over the lower lip. The artist doesn't draw dividing lines for the three planes of the lower lip, but the outer contour is squared slightly to suggest those planes. He also refines the shape of the jaw and chin with additional lines.

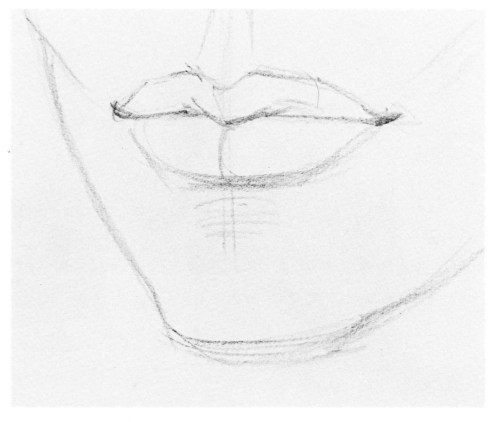

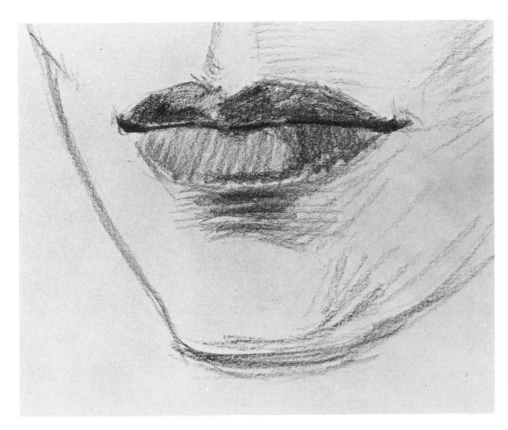

Step 3. The artist begins to darken the upper lip, which is normally in shadow, as you've seen in the preceding demonstrations. He darkens the dividing line between the lips, accentuating the shadows at the corners of the mouth. Just above this dark line, he darkens the shadowy upper lip to emphasize its roundness. He places a light tone on the lower lip, which turns upward and receives the light, but he darkens the shadow plane at the right. Rough strokes darken the pool of shadow beneath the lower lip. He begins to add tone to the side of the chin and jaw. And he adds a heavy shadow to the groove above the upper lip.

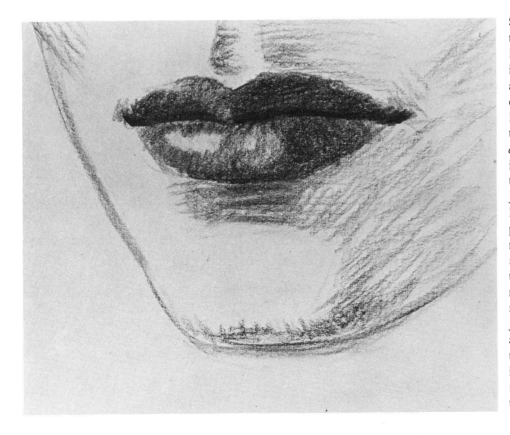

Step 4. The artist continues to darken the shadowy upper lip and strengthens the dividing line between the lips. He adds more tone to the corners of the mouth. Although the lower lip receives more light than the upper one, the lips *are* darker than the surrounding skin—so he adds more tone to the lower lip, leaving just a patch of light for a highlight. He darkens the shadow plane of the lower lip at the right and strengthens the shadowy underside of the lip to make the shape look rounder. Finally, he adds more tone to the chin and jaw, as well as to the groove above the upper lip. Compare the soft, round female mouth in this demonstration with the more angular male mouth in the preceding demonstration.

Step 1. Above the horizontal guideline that represents the dividing line between the lips, the artist draws the upper lip with just a few crisp lines, plus a single line for the curve leading upward to the base of the nose. In the same way, he draws the lower lip with a few angular lines and then carefully draws the shape of the chin with curving strokes. Notice the slanted line that touches the tips of the upper and lower lips at the right. This is an important guideline because it indicates the relationship between the lips: the upper lip normally protrudes farther forward.

Step 2. Working carefully over the sketchy lines of Step 1, the artist redefines the shapes of the lips with darker lines. Notice how the upper lip turns down and slightly overlaps the lower lip. The lower lip recedes slightly and is just a bit thicker than the upper lip. The artist also strengthens the lines of the chin and accentuates the shadowy corner of the mouth.

Step 3. The artist adds broad areas of tone with the side of the lead. You can see clearly that the upper lip is in shadow because it slants downward, away from the light. The lower lip is paler because it turns upward and receives the light. The upper lip casts just a hint of shadow across the lower lip; there's also a hint of shadow along the lower edge. Beneath the lower lip is a concave area that curves away from the light and is filled with shadow. The artist adds more shadow at the corner of the mouth and begins to model the tones of the chin and jaw.

Step 4. The artist darkens the upper lip and accentuates the shadow line between the lips, as well as the dark corner of the mouth. He deepens the pool of shadow beneath the lower lip and adds more strokes to model the entire jaw area, which now becomes rounder and more three-dimensional. Finally, he darkens the forward edge of the lower lip, which receives the shadow cast by the overlapping upper lip. It's interesting to study the pattern of the pencil strokes, which gradually change direction to follow the curving forms of the mouth, chin, and jaw.

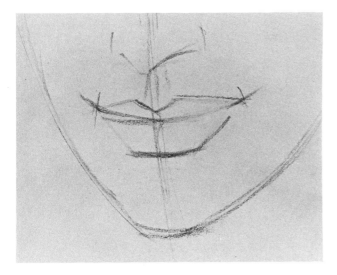

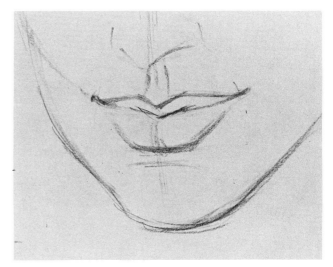

Step 1. When the head turns downward—or when we look at the head from slightly above—we get a different view of the mouth. We see somewhat less of the upper lip and more of the lower lip. (In this drawing, the head is turned slightly to the left, and so we also see more of the right side of the mouth.) As you've seen in previous demonstrations, the preliminary drawing captures the wing shape of the upper lip and the three planes of the lower lip—all with straight, simple lines.

Step 2. The artist redraws the lips with softer, curving lines and gently erases the more angular guidelines of Step 1. Now you see the protruding center of the upper lip, which slightly overlaps the lower lip. The corners of the mouth turn slightly upward and the wing shape of the upper lip becomes more graceful. The artist also strengthens the lines of the chin, the jaw, and the groove between the upper lip and the base of the nose.

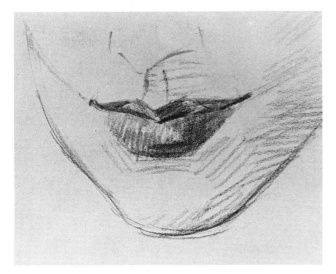

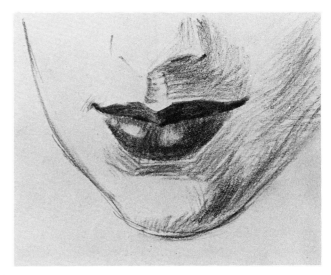

Step 3. The artist darkens the upper lip *selectively*. The upper lip actually has a kind of zigzag shape that's sometimes in light and sometimes in shadow. This is most apparent at the center, where the left plane catches the light and the right plane is in shadow; the artist accentuates the shadow plane to make the shape jut forward. He also darkens the line between the lips, adds tone to the lower lip, darkens the shadow plane at the right, and also darkens the underside of the lower lip to make the shape look rounder. He begins to model the tones on the chin and jaw.

Step 4. As the artist darkens the tones of the lips, it's obvious that the light comes from the left, since the right planes are in shadow. He darkens the right sides of both lips and deepens the shadow line between the lips. He also accentuates the dark corners of the mouth. The shadowy underside of the lower lip is darkened to make the shape look rounder and fuller. An eraser picks out highlights on the rounded lower lip. The artist darkens the shadow area beneath the lower lip and models the soft curves of the chin and jaw.

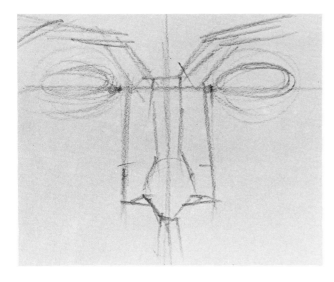

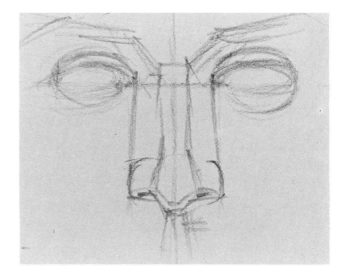

Step 1. The preliminary sketch emphasizes the proportions of the nose in relation to the eyes. The space between the eyes is usually the width of one eye. The artist draws vertical guidelines down from the inner corners of the eyes to indicate the width of the nose—which is about "one eye wide" at the base. These vertical guidelines establish the *outer* edges of the nostrils. Now study the inner guidelines: the diagonals that connect the brow to the bridge; the verticals that define the bridge; and the diagonals that indicate the tip of the nose. The vertical center line aids symmetry.

Step 2. Over the vertical guidelines of Step 1, the artist draws curving lines to define the shapes of the nostrils, plus firm, straight lines to define the tip of the nose more precisely. The artist doesn't draw the nose in isolation but works on the other features at the same time. He begins to define the shapes of the eyes more precisely, since the shape of the nose flows into the eye sockets. He also indicates the shape of the groove leading from the nose to the upper lip.

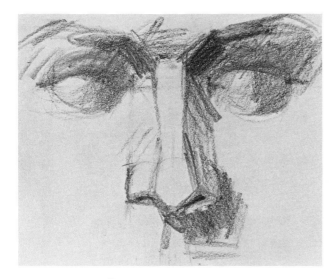

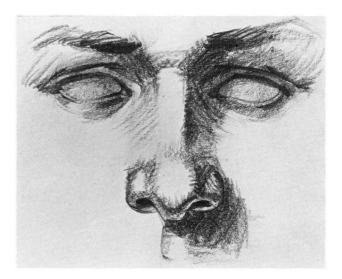

Step 3. With the side of the lead, the artist blocks in the tones with broad strokes. The light comes from the left, and so the right side of the nose is in shadow. Since the nose locks into the eye sockets, the artist adds tone to the sockets at the same time. There's a particularly dark patch of tone in the eye socket at the right, just above the bridge of the nose. The nose also casts a shadow downward toward the right, over the upper lip. The artist erases the guidelines of Step 1, adds tone to the underside of the nose, and darkens the nostrils.

Step 4. The artist now sharpens the contours and builds up the tones. Study the subtle gradation of tone on the shadow side of the nose, as well as the gradations on the tip of the nose and the nostrils. The underside of the nose is in shadow, but there's just enough reflected light within the shadow to define the shapes. Notice how the cast shadow under the nose is paler as the tone recedes downward. There are also deep shadows in the eye sockets on either side of the nose, plus a soft patch of shadow just above the bridge, where the brow slants down, away from the light.

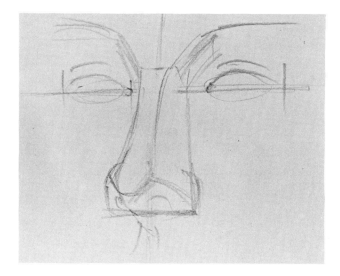

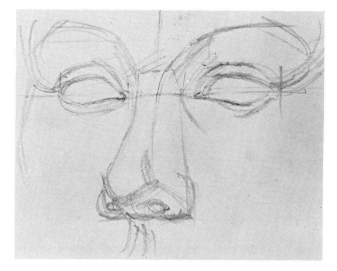

Step 1. When the head turns to a three-quarter view, the nose no longer looks symmetrical; we see more of one side. In this drawing, the head also tilts slightly upward, and so we see more of the underside of the nose. The artist starts with the slanted lines of the brow, leading downward along the eye sockets to the bridge of the nose. The bridge and side plane are indicated by vertical lines that lead down to the base of the nose, which is roughly "one eye wide." Curving lines indicate the nostrils and the tip of the nose. The artist draws the eyes at the same time.

Step 2. Following the guidelines of Step 1, the artist refines the curved shapes of the nostrils, the tip of the nose, and its underside. He also refines the shapes of the eyes and the eye sockets that flow into the sides of the nose.

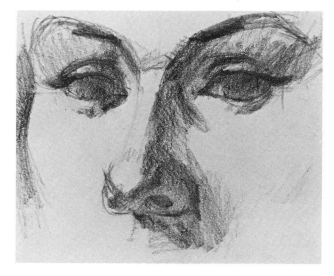

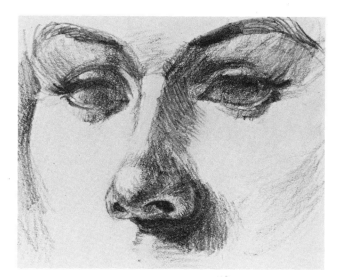

Step 3. The side of the pencil begins to indicate the shapes of the shadows with rough, scribbly strokes. The light comes from the left, and so the right side of the nose is in shadow. So is the underside, which also casts a slanted shadow downward. The artist also begins to model the eye sockets, since their shapes are inseparable from the shape of the nose. You already begin to see the distinction between halftone and shadow on the tip and side of the nose.

Step 4. The artist continues to build up the tones on the shadow side of the nose and around its tip. The wings of the nostrils are clearly defined by darker strokes, as well as by touches of reflected light. Notice that the rounded tip of the nose is modeled as a separate form, very much like a little ball. The artist darkens the eye sockets on either side of the nose to make the bridge stand out more distinctly. He's erased the guidelines of Step 1 and continues to work on the surrounding features as he works on the nose.

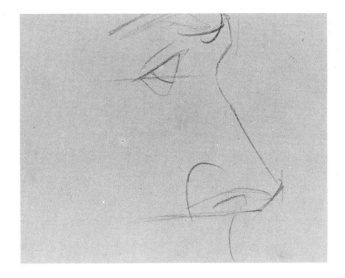

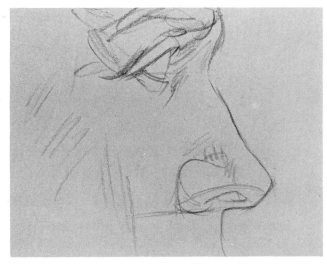

Step 1. Drawing the nose in profile, the artist carefully follows the horizontal guidelines that locate the eye and the base of the nose. He draws the brow and the eye at the same time to establish an accurate relationship between the features. The eye is just above the bridge of the nose and aligns with the concave curve beneath the brow. The back end of the nostril wing lines up roughly with the forward edge of the upper eyelid. The nose itself is drawn with just a few straight lines and a few curves.

Step 2. The artist draws the contours more precisely over the guidelines of Step 1—and then erases most of them. Now there's a distinct S-curve from the bridge of the nose down to the tip. The underside of the nose is clearly defined as a separate plane. The curving shape of the nostril wing is more carefully drawn. The artist also refines the curve of the brow and continues to work on the eye as he draws the nose. A few strokes divide the tip of the nose and the nostril into separate shapes—this division will become more important when tone is added in Steps 3 and 4.

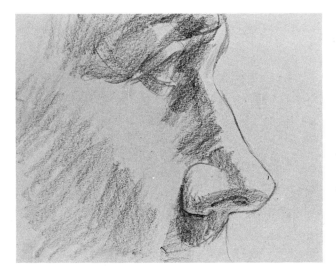

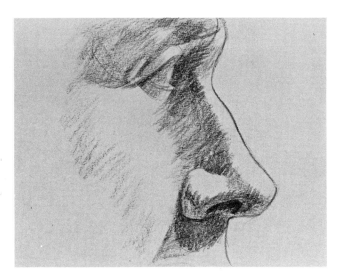

Step 3. The artist begins to block in the tones with broad strokes, using the side of the pencil lead. The light comes from the left, and so the front plane of the nose is in the light, while the side plane is in shadow. The underside of the nose and the back of the nostril are also in shadow, while the front plane of the nostril catches the light. Notice that a patch of shadow now divides the tip of the nose from the nostril. There's also a patch of deep shadow in the eye socket.

Step 4. As the artist strengthens his dark tones, you begin to see a clear distinction between light, halftone, and shadow on the side of the nose and on its underside. The artist deepens the shadow on the eye socket and darkens the nostril. With the sharp point of the pencil, he draws the contours of the brow, nose, and upper lip more exactly. Notice a hint of shadow where the brow turns downward, away from the light. And observe how the slanted strokes of the pencil accentuate the three-dimensional character of the forms.

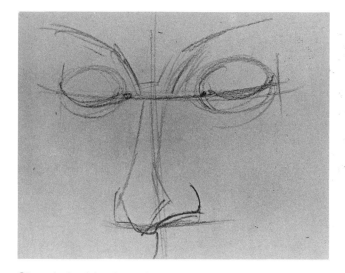

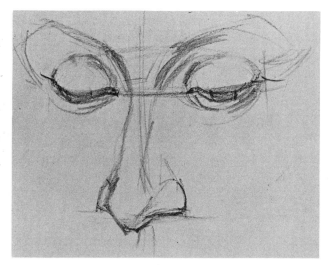

Step 1. In this view of the nose, the head tilts slightly downward, and so we see very little of the underside of the nose. The head is also turned slightly to the left, and so we see more of the right side and very little of the left. In this preliminary sketch, the artist visualizes the tip of the nose as a kind of diamond shape. The undersides of the nostrils look like curves. The outer edges of the nostril wings still align with the inside corners of the eyes.

Step 2. The artist continues to define the rounded shapes of the nostrils more precisely. He sees very little of the nostril on the left and a great deal of the one on the right. The tip of the nose seems to hang downward, since we're looking at it from slightly above. The artist redraws the bridge of the nose, which widens slightly just above the eyes. He works on the eyes at the same time that he draws the nose. Because the head and eyes turn downward, we see a great deal of the upper eyelids.

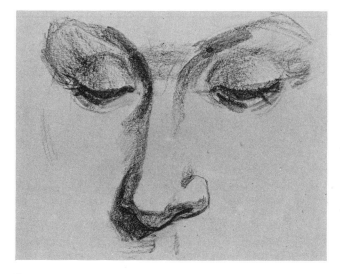

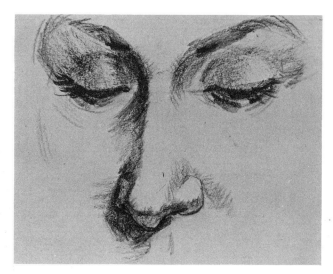

Step 3. The light comes from the right, and so the artist builds up the tones on the left sides of the forms. The left side of the nose is in shadow. So is the underside, which casts a slanted shadow downward toward the upper lip. The artist carefully models the inner curves of the eye sockets, which define the top of the nose. In particular, notice the dark curve of the eye socket at the left, which swings around the bridge of the nose.

Step 4. The artist continues to darken the inner curves of the eye sockets; these tones make the bridge of the nose seem more three-dimensional. He darkens the tone on the shadow side of the nose; now you see a clear gradation of light, halftone, and shadow. He models the tip of the nose as if it's a little ball. He models the nostril at the right as a separate shape, surrounded by tone. The pencil point sharpens the contours of the underside of the nose. At the right of the lighted nostril wing, a hint of tone suggests the inner edge of the cheek.

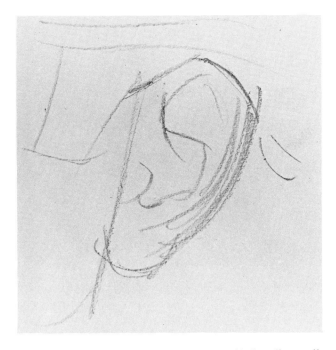

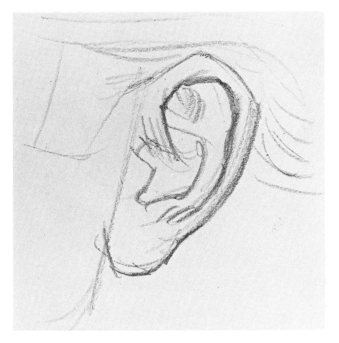

Step 1. The artist begins by drawing a guideline diagonally upward from the jaw. The ear attaches to this line. He draws the top of the ear with two angular lines and then moves downward to draw the back of the ear with a big curve and the lobe with a smaller curve. Carefully observing the inner detail of the ear, he draws the shapes with short, curved strokes.

Step 2. Over the sketchy lines of Step 1, the artist draws the contours of the ear with darker, more precise lines. A dark inner line defines the sinuous shape of the rim, which winds around to the deep "bowl" at the center of the ear. The artist draws the inner shape more exactly.

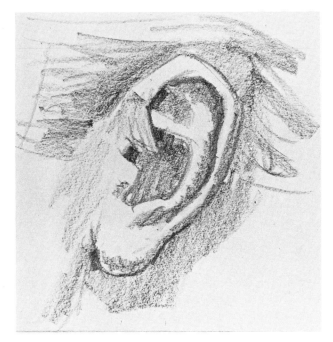

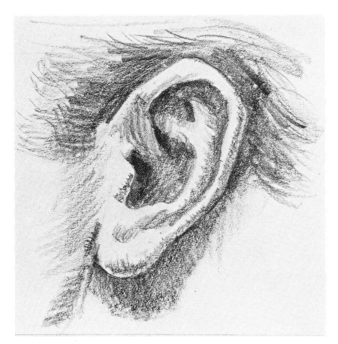

Step 3. The artist adds the pools of shadow within the ear, which is darkest just inside the rim. He moves around the outer edge of the ear and around the lobe, adding touches of shadow that make the shape look three-dimensional. He suggests the hair surrounding the ear snd begins to model the cheek and jaw. Notice the tiny pool of shadow where the lobe attaches to the jaw.

Step 4. The pools of shadow within the ear are darkened with heavy strokes. Small parallel strokes strengthen the tones around the edge of the ear; then an eraser brightens the lighted areas. The ear casts a shadow downward on the back of the neck. The artist completes the surrounding hair, making the rounded forms of the ear stand out more boldly.

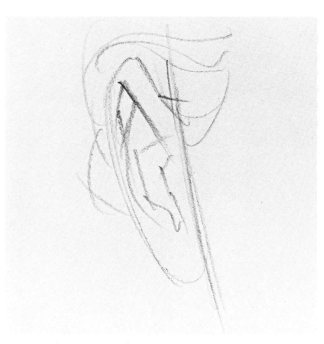

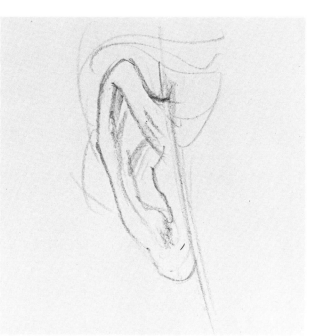

Step 1. When the sitter faces you, you see much less of the ear. The shape grows slender. The artist begins by drawing the slanted line of the jaw and cheek, to which the ear attaches. He draws the outer shape of the ear with just a few straight lines and curves, and then draws the inner shape with shorter lines. He indicates the hair that surrounds the ear.

Step 2. Step 1 is a highly simplified version of the ear, of course. Now the artist goes back over these sketchy lines to define the shapes more precisely. He draws the intricate curves and angles over the guidelines—which he then erases.

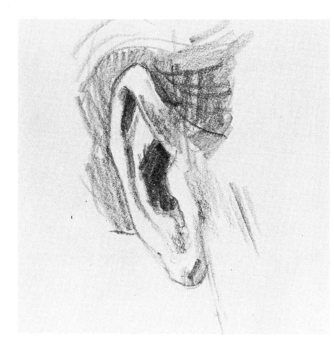

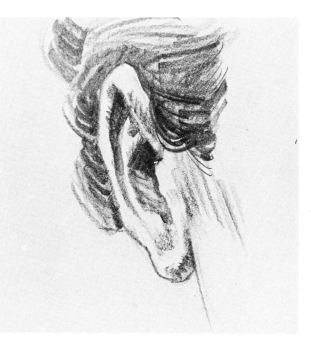

Step 3. With the side of the pencil, the artist blocks in a big pool of shadow at the center of the ear, plus the slender shadow that starts at the top and travels down along the inside of the rim. He begins to model the lobe and the portion of the ear that attaches to the side of the head. The tone of the hair is blocked in to make the lighted edge of the ear stand out.

Step 4. The side of the pencil deepens the inner tones of the ear. Then an eraser lightens the lower half of the big pool of shadow. A few additional touches of tone appear on the rim and lobe of the ear. The tone of the hair is carried carefully around the ear and helps to define its shape. In this view, we see a minimum of detail; the ear is drawn very simply.

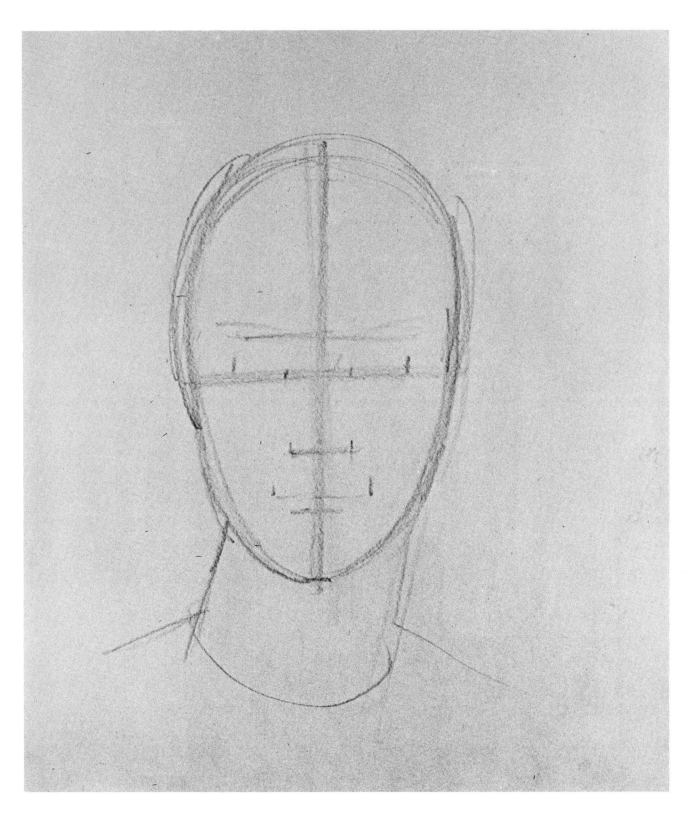

Step 1. Now, to show you how to put together everything you've learned so far, the artist draws a front view of a complete head. He starts out with the traditional egg shape and visualizes the neck as a slightly slanted cylinder. For symmetry, he draws a vertical guideline down the center of the egg. Then he adds horizontal guidelines for the brow, eyes, nose, and mouth. He divides the eye line into five different parts: two of these parts will become eyes, of course, but the space *between* them is also the width of one eye—and so are the spaces on either side of the eyes. The base of the nose is also "one eye wide." The mouth is about "two eyes wide."

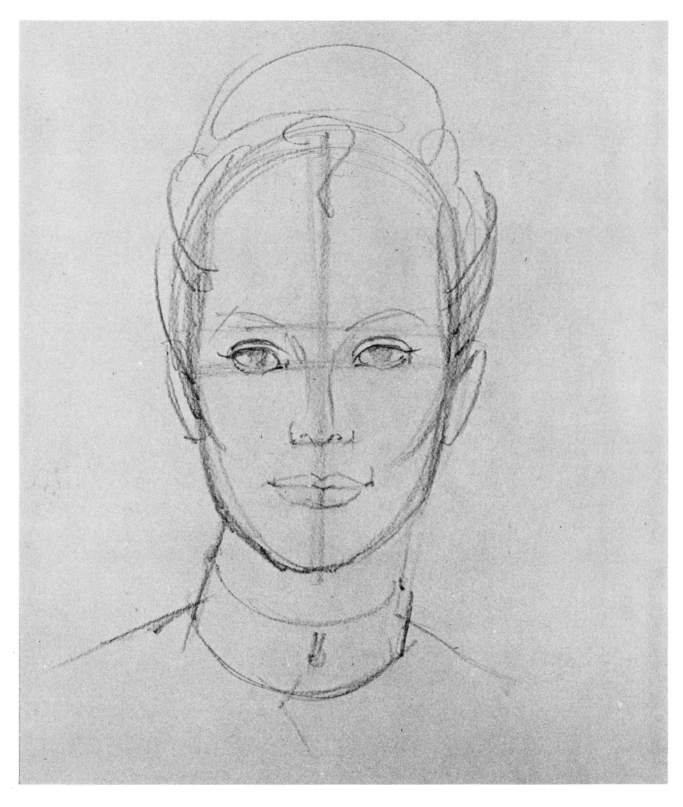

Step 2. The first simple sketch of the features goes directly over the guidelines of Step 1. The artist squares up the jaw just a bit, adds the ears—which align with the nose and eyes—and suggests the shape of the hair, which extends beyond the edges of the egg. He draws the lines of the eyelids and suggests the shape of the iris. He quickly sketches the bridge of the nose, the shapes of the nostrils, and the tip. He draws the characteristic wing shape of the upper lip and the fuller curve of the lower lip. The sitter's collar curves around the cylinder of the neck.

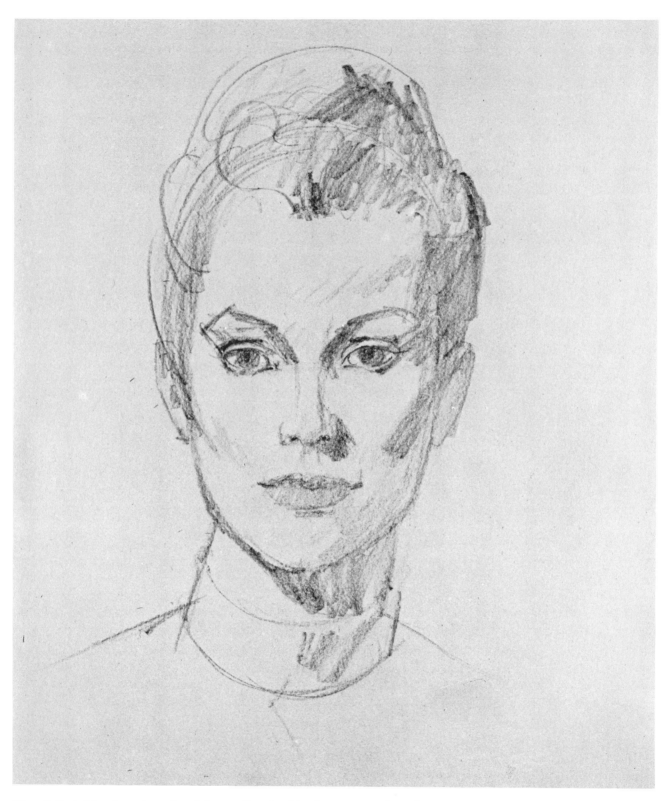

Step 3. Switching from the point of the pencil to the side of the lead, the artist begins to darken his tones with broad parallel strokes. The light comes from the left, and so most of the tones are on the right sides of the shapes. He carries the tone downward over the side of the forehead, cheek, jaw, and chin, adding the shadow on the neck. He adds the first suggestion of tone to each eye socket, iris, and pupil, and then moves downward to add broad, simple tones to the nose and lips. As usual, the upper lip is darker than the lower, and there's a shadow beneath the lower lip. Touches of tone appear on the ears. The hair is visualized as a big, simple mass, lighter on one side than on the other.

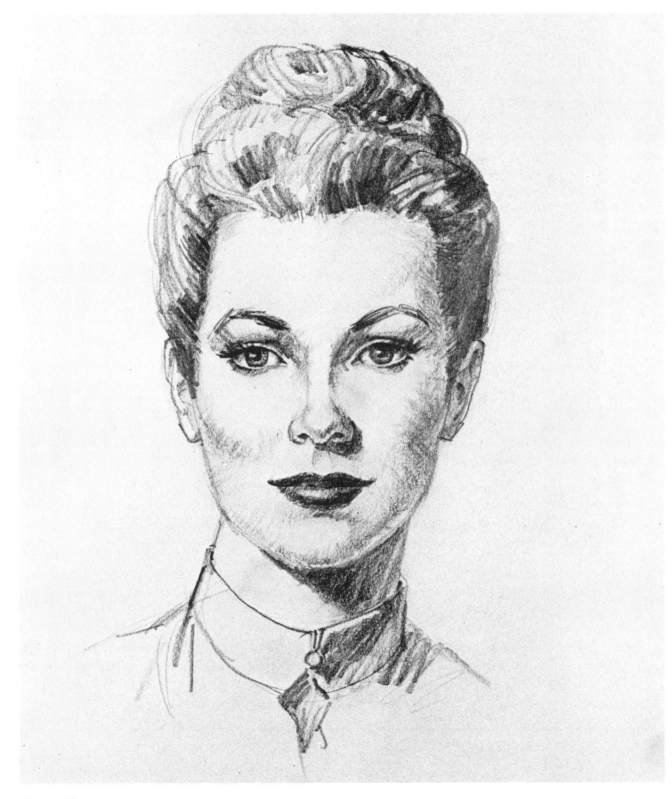

Step 4. The artist completes the drawing by darkening the tones with the side of the pencil and sharpening contours and details with the tips. He builds up the modeling on the shadow side of the face, where you can now see a distinct gradation of light, halftone, shadow, and reflected light. On the lighted side of the face, he adds touches of tone where the cheek and jaw turn away from the light. He darkens the eye sockets, the underside of the nose and nostrils, the lips, the tones within the ears, and the shadow beneath the chin. With the point of the pencil, he sharpens the contours of the ears, emphasizes the detail of the eyes and eyebrows, draws the nostrils more precisely, and suggests the detail of the collar. He completes the hair with broad strokes made with the side of the lead.

Step 1. The procedure is essentially the same in a three-quarter view. But now the guidelines are a vertical egg overlapped by a horizontal egg. The center line moves as the head turns to the side. The horizontal guidelines are still in the same places, of course. Across the eye line, the artist locates the eyes with tiny touches of the pencil point. Moving down to the line at the base of the nose, he locates the outer edges of the nostrils in the same way. The neck is a slightly slanted cylinder once again. Notice that the back of the head protrudes well beyond the line of the neck.

Step 2. The artist reshapes the contours of the head over the original guidelines, adding the angular details of the brow, cheek, chin, and jaw. The features appear in their correct places on the horizontal guidelines. Although the head is turned to a three-quarter view, the ear still aligns roughly with the eyebrow and nose. Notice how the tip of the nose and the nostrils are visualized as distinct forms. The eyelids are clearly drawn, as are the dark patches within the eyes. The upper lip has the distinctive wing shape, while the lower lip looks blocky and masculine. The hair starts just below the crown and extends beyond the guidelines of the upper egg shapes.

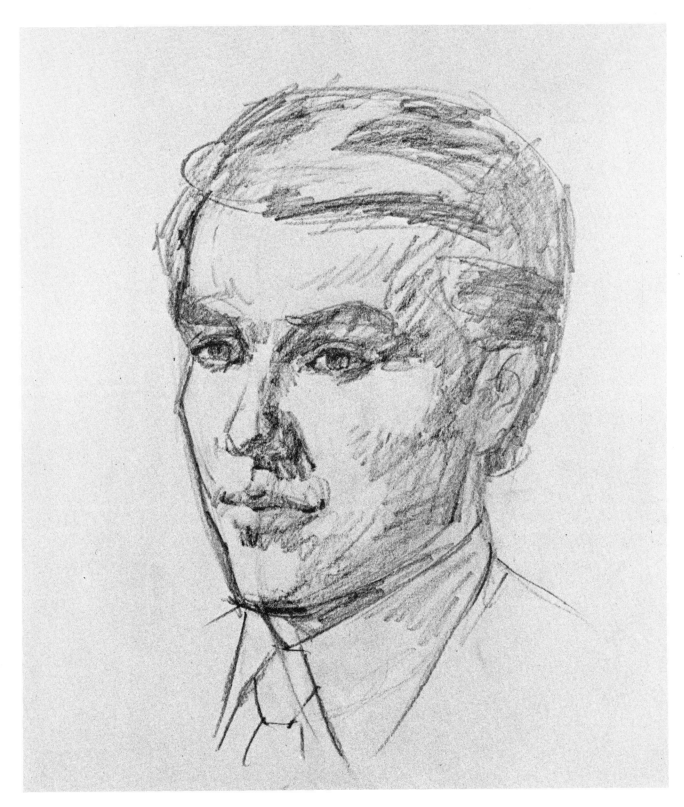

Step 3. The artist blocks in the tones with rough strokes. First he places the biggest tonal shapes on the side of the brow, cheek, jaw, and chin. Then he moves to the features, adding tone to the eye sockets, eyelids, nose, and lips. The nose casts a slanted shadow downward toward the right. As usual, the upper lip is in shadow, the lower lip catches the light, and there's a deep shadow beneath the lower lip.

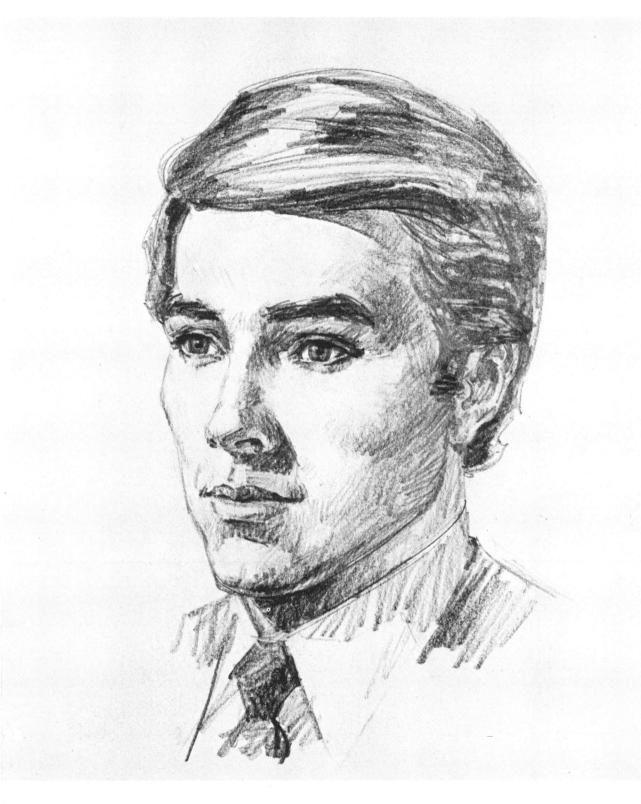

Step 4. The artist finishes the drawing by building up the darks throughout the face and features, and so now you can see the lights, halftones, shadow, and reflected light distinctly. The point of the pencil sharpens the lines and adds the details. Is this four-step process becoming familiar? Good!

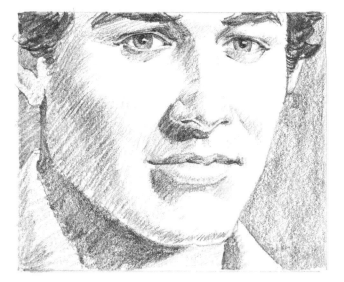

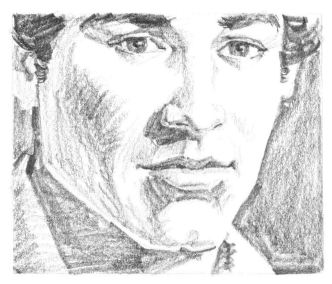

Slender Strokes. Working with the sharp point of the pencil, you can build up the tones of your drawing with groups of slender parallel strokes. The halftones and reflected lights are clusters of fairly pale strokes; the artist has applied only moderate pressure to the pencil. The darker shadows consist of heavier strokes; the artist has pressed harder on the pencil. The strokes are closer together in the shadow areas, while there are more spaces between the strokes in the halftones and reflected lights. Observe how the strokes change direction to suggest the curve of the cheek.

Broad Strokes. Here's the same subject executed with much broader strokes. The artist holds his pencil at an angle so the *side* of the lead touches the paper. He presses harder on the pencil to make the darker strokes, which are closer together than the paler strokes. The pencil moves diagonally (with a slight curve) to suggest the roundness of the cheek. Then the pencil moves vertically downward to suggest the squarish shape of the jaw. And the strokes become slanted again as the pencil follows the angle of the jaw down to the chin.

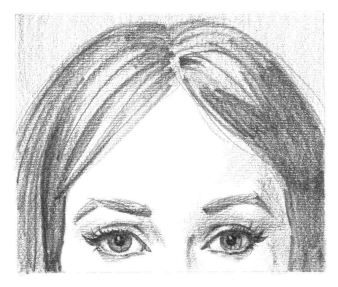

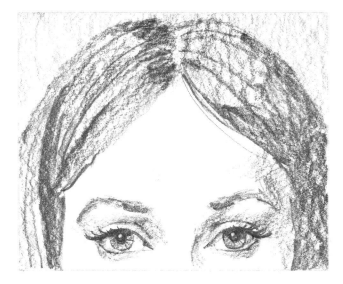

Strokes on Charcoal Paper. Charcoal paper isn't just for charcoal drawing. Its subtle, ribbed surface is equally good for pencil drawing. The delicate *tooth* (as it's called) of the sheet combines with the pencil strokes to produce a lively texture. In this close-up of a woman's portrait, the thick-and-thin pencil strokes in the hair are softened by the textured surface of the paper: tiny flecks of bare paper pop through even the darkest tones, making the strokes vibrate with a kind of inner light. These tiny flecks of bare paper lend softness and transparency to the tones around the eyes.

Strokes on Rough Paper. It's worthwhile to try a variety of textured papers, many of which are rougher and more irregular than charcoal paper. In this portrait of the same woman you see on the left, the artist has used a thick stick of graphite in a plastic holder and drawn on extremely rough paper. The thickness of the drawing tool and the irregular surface of the drawing paper combine to make the strokes look bold and ragged. The marks of the graphite stick look granular, with big flecks of bare paper showing through. The strokes are less precise than those on the charcoal paper, but more dynamic.

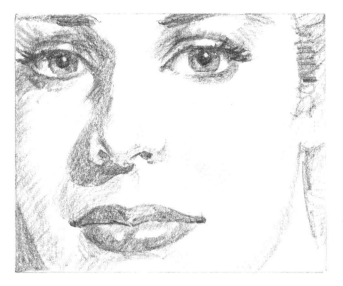

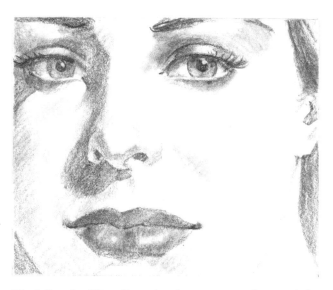

Modeling with Strokes. This woman's face is modeled with delicate strokes that travel carefully over the forms. For example, there are two patches of tone above the right eye socket; each consists of slanted strokes that are carefully angled to express the roundness of the form. Now follow the route of the strokes that model the cheek on the shadow side of the face. In the pale halftone area under the eye, the lines are delicate diagonals. As the cheek turns away from the light, the strokes curve and darken. The entire face is rendered with carefully planned groups of strokes.

Modeling by Blending. Another way to render tone is by blending the strokes of the pencil (or the graphite stick) with the tip of your finger or a paper stomp. Look carefully at this drawing of the same sitter and you'll see that the artist has started with broad, rather casual strokes—not as neat or careful as the ones in the drawing at your left—and smudged them to create soft, velvety tones. The blending doesn't obliterate the strokes completely, but they melt away into smoky areas that look more like patches of paint. The softer grades of pencil are easiest to blend.

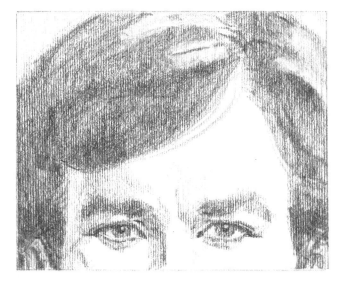

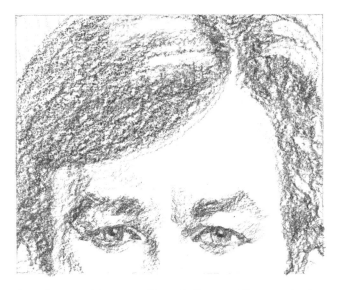

Continuous Tone on Charcoal Paper. Still another way to build up tone on charcoal paper is to rub the side of the lead gently back and forth as if you were sharpening the lead on a piece of sandpaper. The tooth of the paper gradually shaves away microscopic granules of graphite, which slowly pile up to create the tones of the drawing. The more you rub—and the harder—the darker the tones get. For the delicate tones of the eyes, the artist passes his pencil lightly over the paper once or twice. To create the darker tones of the eyebrows and hair, the artist presses harder and moves his pencil back and forth several times.

Continuous Tone on Rough Paper. You can do the same thing on rough paper, which shaves away the granules of graphite more rapidly—like rough sandpaper—and builds up more ragged, irregular tones. Once again, the artist presses harder and moves his pencil back and forth several times for the dark tones, while he just skims the surface of the paper once or twice for the paler tones. He works with a thick, soft pencil—or a graphite stick in a holder.

Step 1. For your first pencil portrait, see what you can do with a combination of slender lines and broad strokes on an ordinary piece of drawing paper. Use the sharp point of the pencil to draw the contours with slender lines. Then use the side of the pencil to build up the tones with strokes of various thicknesses. The artist begins this demonstration by drawing the usual egg shape of the head. Within the egg shape, he draws a vertical center line and four horizontal lines to help him locate the features. Over these guidelines, he draws the eyebrows, eyes, nose, and mouth. The neck is a slightly slanted cylinder around which he draws the curved lines of the collar with swift strokes. A few more lines define the curving contours of the hair, which extends above the egg shape and beyond it on either side. At this stage, the artist works entirely with a sharpened HB pencil.

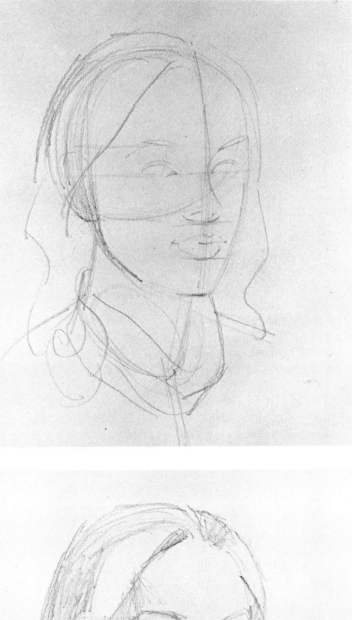

Step 2. The artist switches to a 2B pencil and holds it so that the side of the lead strikes the paper and makes broad strokes. Moving swiftly over the paper, the artist blocks in the major areas of tone with scribbly parallel strokes. The light comes from the right, and so the artist indicates areas of tone on the left side of the brow, cheek, jaw, and neck. He also places a tone on the left side of the nose and suggests the darkness of the eyes and lips. He models the hair as just a few big shapes, blocking in big tonal areas and paying no attention to individual strands or curls. Finally, he scribbles in a band of shadow along the underside of the collar and a triangle of tone inside the collar. In this step, the artist's purpose is simply to divide the portrait into zones of light and shadow. So far, there's no gradation of tone—no distinction between halftone, shadow, and reflected light.

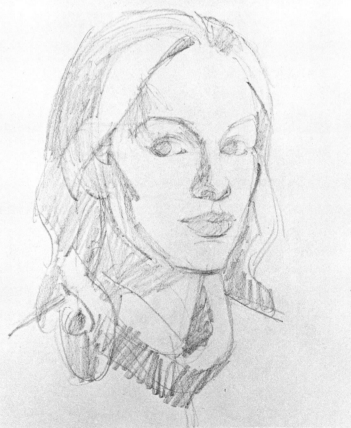

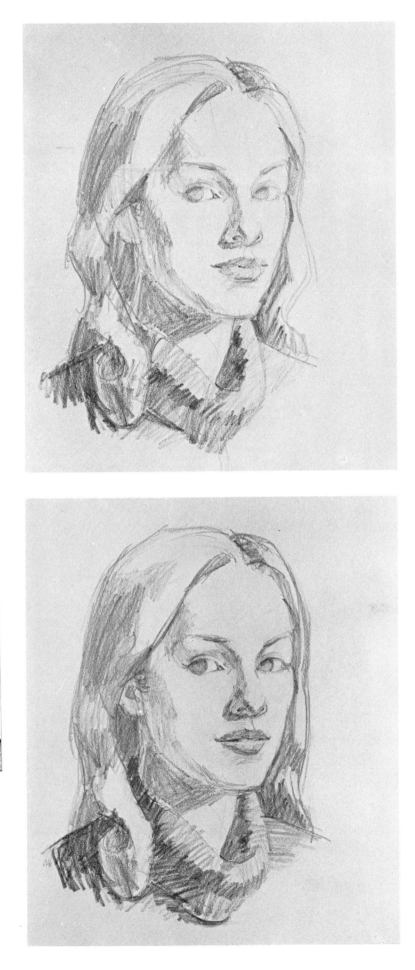

Step 3. Still working with the side of the 2B pencil, the artist begins to darken his tones selectively. He strengthens the shadows on the brow and cheek; around the eyes, nose, and mouth; and on the neck. Now, as usual, the upper lip is in shadow and there's a hint of shadow beneath the lower lip. The tip of the nose casts a small shadow downward toward the corner of the mouth. The artist also darkens some of the tones on the hair and strengthens the tones of the collar. At this point, the artist starts to develop gradations within the tones, and so you begin to see areas of light, halftone, shadow, and reflected light. For example, notice the pale tone at the edge of the jaw, where the shadow gets lighter. The artist still pays very little attention to details, although he does sharpen the corners of the eyelids, nostrils, and mouth.

Step 4. Having established the broad distributions of tones in steps 2 and 3, the artist begins to focus his attention on the features. Working with the 2B pencil, he darkens the eyebrows and the eyes, sharpening the lines of the eyelids with the point of the pencil. Moving downward from the eyes, he strengthens the shadow on the side of the nose and the tones around the tip of the nose. He darkens the upper lip and the shadow beneath the lower lip, sharpening the line between the lips. He uses an eraser to pick out a small strip of bare paper to suggest the teeth and the lighted patch at the center of the lower lip. He draws the darkened center of the ear and shapes the contour of the ear more precisely. With the point of the pencil, he sharpens the edge of the face at the right and clears away excess lines with an eraser. He draws the contours of the hair more distinctly—particularly where the hair overlaps the brow—and brightens the top of the hair by erasing a whole cluster of lines that existed in Step 3. And he builds up the shadows on the collar and shoulder.

Step 5. The artist continues to sharpen details and refine tones. With the tip of the pencil, he draws the eyebrows and eyelids more distinctly, adding the pupils and a suggestion of lashes. With clusters of short, slender strokes, he builds up the tones in the eye sockets and along the side of the nose, sharpening the contours of the nose and darkening the nostrils. He defines the shape of the lips more clearly and darkens them with short, slender, curving strokes. With the same type of strokes, he goes over the shadows on the side of the face to make the gradations more distinct; darkens the tone along the chin; and strengthens the shadow on the neck. It's interesting to see how the character of the pencil strokes has changed. In Steps 2, 3, and 4, the artist worked with broad strokes. Now, in Step 5, he goes back over these broad strokes with more delicate, slender touches to refine the tones.

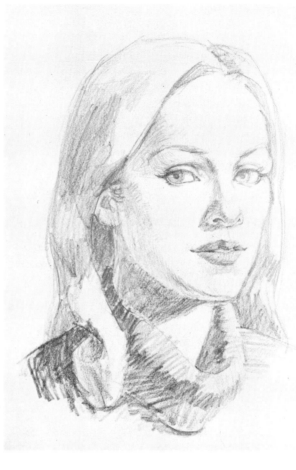

Step 6. At this point, the artist concentrates mainly on detail. He continues to sharpen and darken the contours of the eyes, strengthening the irises and pupils, picking out tiny highlights with a touch of a pointed eraser, and suggesting more lashes. The few additional strokes suggest individual hairs within the eyebrows. Traveling down the side of the nose, he darkens the shadow with delicate strokes and then strengthens the tones around the tip of the nose, where the nostrils and the cast shadow are even more distinct. He darkens the lips and sharpens the contours, paying particular attention to the slender strips of darkness between the lips. With slim, curving strokes, he carries the halftone of the jaw farther upward toward the cheek. Switching back to the sharply pointed HB pencil, he goes over the hair to suggest individual strands with crisp strokes.

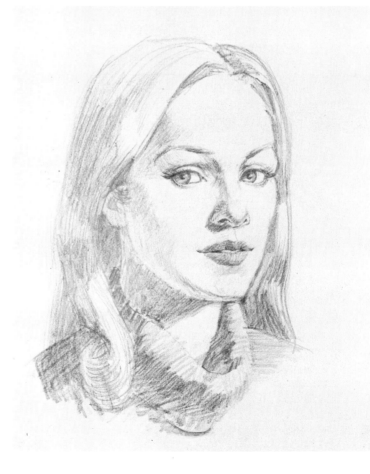

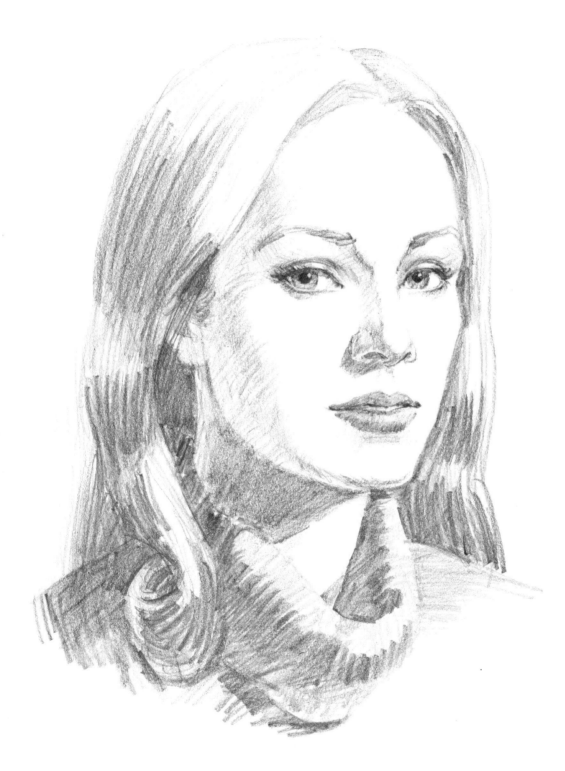

Step 7. The side of the 2B pencil deepens the tones with broad, bold strokes. Clusters of broad strokes move down over the hair to darken the shadow; the strokes are distinct enough to suggest the texture of the hair. The pencil point darkens the contours of the eyes, the tones on the side of the nose, and the tones of the lips; then it picks out more hairs within the eyebrows and more eyelashes. The pupils grow darker, as do the shadows beneath the upper lids. Finally, a kneaded rubber eraser cleans the lighted areas.

Step 1. Now try drawing a pencil portrait that consists mainly of broad, bold strokes. Use a thick, soft pencil or a thick, soft stick of graphite in a holder. In this first step, the artist begins by drawing the side view of the head with the usual overlapping egg shapes, one vertical and one horizontal. Just two lines define the neck as a slanted cylinder. Horizontal guidelines locate the features. The artist works with the sharpened tip of the thick lead.

Step 2. Continuing to work with the point of the thick lead, the artist draws the contours of the face over the guidelines of Step 1. He begins by drawing the profile: the brow, nose, lips, and chin. Then he steps inside the profile to place the eyebrow, eye, nostril wing, lips, ear, and corner of the jaw. Just two lines suggest the Adam's apple on the front of the neck. The pencil sweeps around the top and back of the horizontal egg to indicate the shape of the hair. Notice how the ear aligns with the eye and nose, while the sharp corner of the jaw aligns with the mouth.

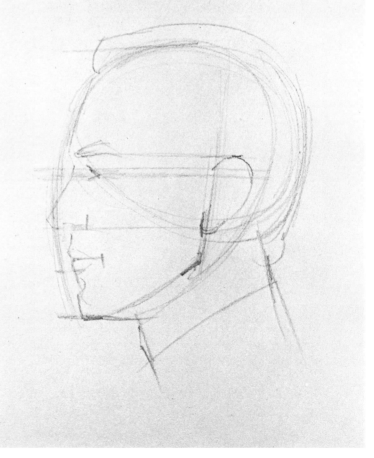

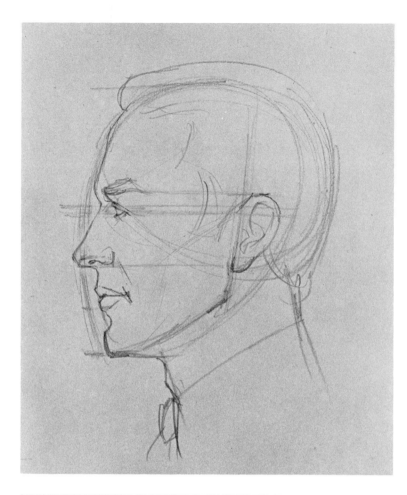

Step 3. Moving more carefully over the lines of Step 2, the artist refines the contours with the tip of the pencil. The sitter has an angular, bony face, which the artist records faithfully. He draws the bulge of the forehead, the sharp brow, the precise S-curve of the nose, the crisp detail of the lips, and the squarish chin. Moving inside the outer edge of the profile, the artist draws the eyebrow, eye, nostril, mouth, and ear with great care. Just a few lines indicate the sideburn and the dividing line between skin and hair on the side of the forehead. Note the internal detail of the ear.

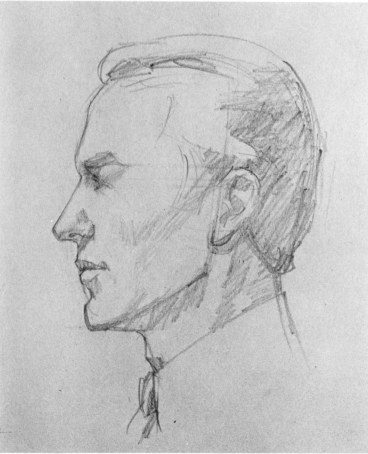

Step 4. With a pink rubber eraser, the artist removes most of the guidelines that appeared in Steps 1, 2, and 3. Now he can see the lines of the profile and features more clearly and begin to block in the tone. Turning the thick pencil on its side, the artist begins to render the tones surrounding the eyes and nose, the cast shadow beneath the nose, the dark tone of the upper lip, and the pool of shadow beneath the lower lip. Broad, free strokes fill the underside of the jaw with shadow, indicating the interlocking patches of shadow that move from the underside of the cheek down to the jaw. Patches of shadow are placed on the hair, within the ear, beneath the ear, and at the back of the neck. All the tones are still quite pale, but the purpose of this fourth step is simply to establish the major areas of light and shade.

Step 5. The artist begins to build up the gradations within the tones. He darkens the eyebrow and the tones within the eye socket, then moves downward to build up the tones of the nose and lips. He sharpens the nostril and the shadow beneath the nose, and then he strengthens the shadow of the upper lip. He also darkens the tones within and around the ear. Focusing on the larger areas of the face, he strengthens the shadows on the cheek, jaw, neck, and hair. The tip of the pencil defines the contours of the ear more precisely and draws the squarish shape of the sideburn.

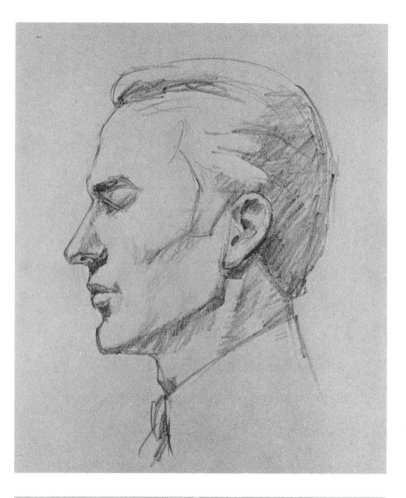

Step 6. Gradually, the strokes of the side of the thick pencil become more distinct as the artist continues to build up the tones. Observe the short, decisive strokes that model the eye sockets, the side of the nose, the corner of the mouth, and the tone that travels downward from the cheek to the jaw. The artist darkens the underside of the jaw with broad, distinct strokes that accentuate the squarish, bony shape. The hair is darkened with thick strokes that suggest texture and detail. With the sharp tip of the pencil, the artist begins to emphasize the features. He darkens the eyebrow and sharpens the lines of the eyelids. He adds crisp touches to define the contours of the nostril, lips, and ear more precisely. Notice the tiny accents of darkness within the nostril, at the corner of the mouth, between the lips, and within the rim of the ear.

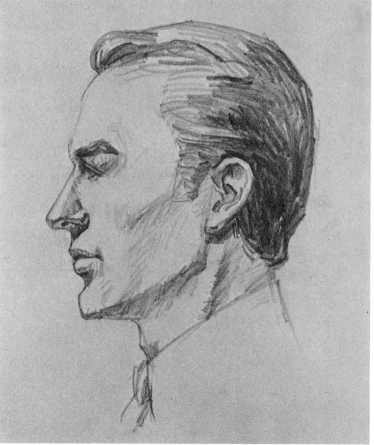

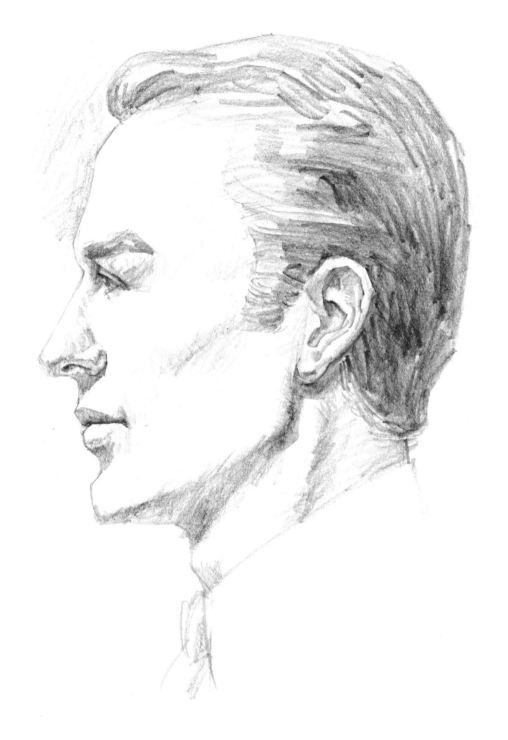

Step 7. The pencil moves over the face, adding clusters of parallel strokes that enrich the tones of the brow, cheek, jaw, and neck. More strokes darken and model the eye socket, nose, lips, and ear. The sharpened point of the pencil delicately retraces the contour of the profile and sharpens the eyelids, nostril, lips, and ear. The side of the pencil darkens the hair with thick strokes and adds a hint of tone on the bare paper along the edge of the brow—accentuating the light on the sitter's bony forehead.

Step 1. The rich skin tones of a black sitter will give you an opportunity to try a pencil-drawing technique that combines strokes with blending. For this technique, a sheet of charcoal paper is particularly suitable, since the delicately ribbed surface softens the strokes and also lends itself beautifully to blended tones executed with a fingertip or a stomp. The artist begins his demonstration with the standard egg shape divided by a vertical center line, plus horizontal lines for the eyes, nose, and mouth. Notice that there's just one horizontal line for the eyes, above which the artist will place the eyebrows. The lowest horizontal line locates the bottom edge of the lower lip, which is halfway between the nose and chin. The artist visualizes the neck as a slightly tilted cylinder. Notice that he doesn't hesitate to go over these guidelines several times until he gets the shape exactly right. Because this demonstration requires so much blending, the artist selects a soft, thick 4B pencil.

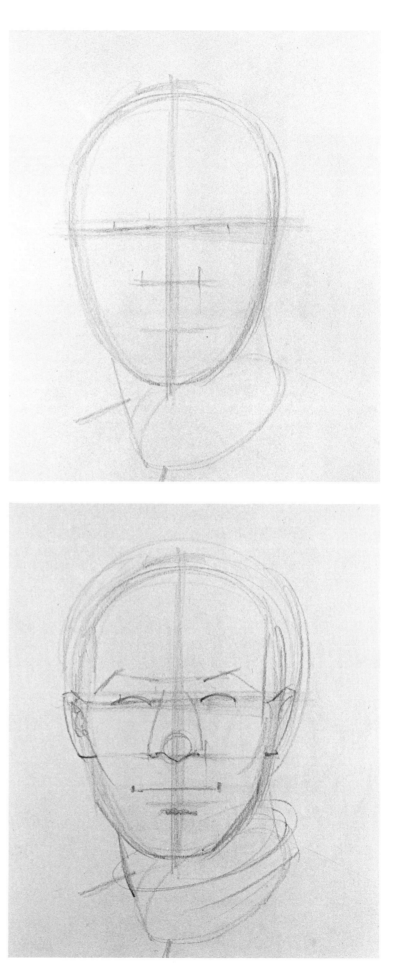

Step 2. Working with the sharpened tip of the pencil, the artist locates the eyes on the horizontal guideline that crosses the midpoint of the head, and then he places the brows above this line. On either side of the vertical center line, he establishes the outer contours of the nose, and then he moves down to locate the tip of the nose and the nostrils on the next horizontal guideline. He places the ears between the guidelines of the eyes and nose. On the lowest horizontal guideline, he makes a dark stroke to indicate the deep valley beneath the lower lip. Then he places the dividing line of the lips roughly one-third of the way down from the nose to the chin. He squares up the corners of the jaw, indicates the curves of the cheeks, and swings the line of the collar around the cylindrical shape of the neck. Moving outward from the top and sides of the egg, the artist indicates the shape of the hair.

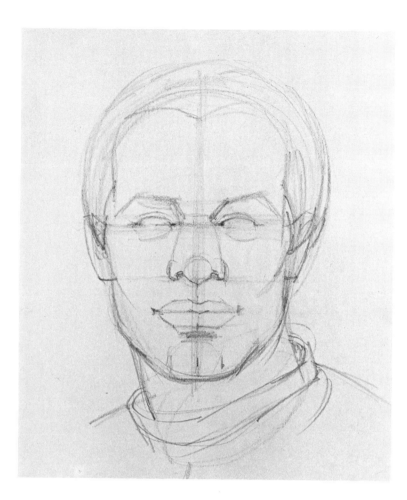

Step 3. With the point of the thick pencil, the artist now defines the shapes of the head and features more exactly. He redraws the contours of the cheeks, jaw, chin, and neck directly over the original guidelines of Steps 1 and 2. The pencil point carefully traces the hairline. Then the artist focuses on the features: he sharpens the contours of the eyebrows and draws the upper and lower lids; defines the shapes of the nostrils and the tip of the nose; constructs the planes of the lips; and emphasizes small, significant details such as the corners of the eyes, the corners of the lips, and the cleft in the chin. Finally, he draws the irregular curves of the collar.

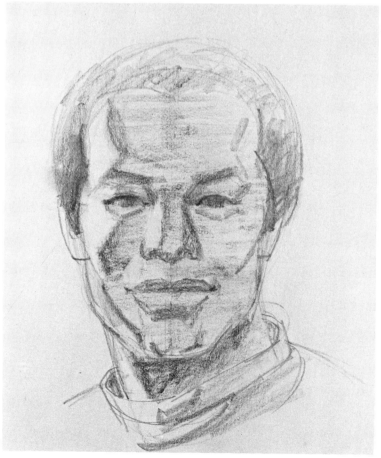

Step 4. Turning the thick pencil on its side, the artist begins to block in the tones with broad strokes. The light comes from the left, placing most of the head in shadow. This head is an example of what artists call *rim lighting*. There's a strip (or rim) of light along one edge of the face, neck, nose, and upper lip, but the rest of the face doesn't receive direct light. There's a dark edge where the light and shadow planes meet; the artist accentuates this by pressing his pencil harder at the edges of the lighted areas on the forehead, cheek, jaw, neck, and nose. He covers the shadowy areas of the face with broad horizontal strokes and then emphasizes the strong darks *within* the shadow areas: the brows, eye sockets, and eyes; the bridge of the nose and the nostrils; the upper lip and the dark tones beneath the lower lip; the chin; and the shadow beneath the neck. The artist also begins to darken the hair and the shadow side of the collar. By the end of this step, there's a clear distinction between the light and shadow areas.

Step 5. The artist begins to deepen the tones by moving the flat side of the pencil back and forth over the face. The broad strokes are most apparent in the forehead and cheek, where you often see big gaps between the strokes—although these gaps will disappear when the artist begins to blend the tones. He strengthens the dark areas where the light and shadow planes meet on the side of the face, nose, and upper lip. He darkens the hair, the shadow on the neck, and the shadow side of the collar. Then he moves inside the face to strengthen the contours and to darken the tones of the eyebrows, eyes, nose, and lips. With the point of the pencil, he emphasizes the dark edges of the eyelids, nostrils, and lips.

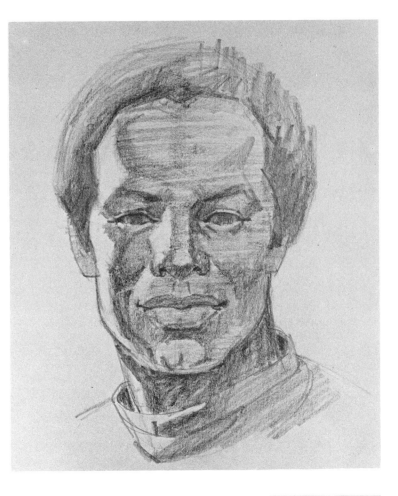

Step 6. Pressing still harder and moving the side of the pencil back and forth over the textured paper, the artist strengthens all the darks within the shadow planes of the face. He darkens the tones within the eye sockets, along the bridge of the nose, beneath the nose and cheeks, within the lips, around the chin, and on the neck. With short, curving, scribbly strokes, he darkens the tone of the hair to suggest its curly texture. And with the tip of the pencil he sharpens all the features, indicating such details as the pupils of the eyes, the shadow lines around the nostrils, and the dark line between the lips.

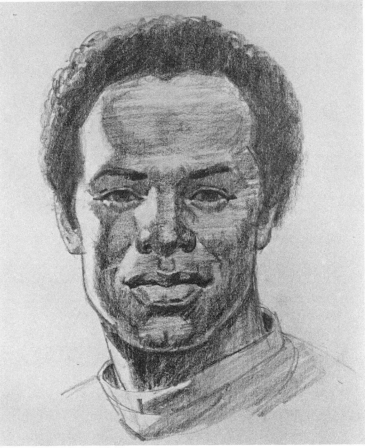

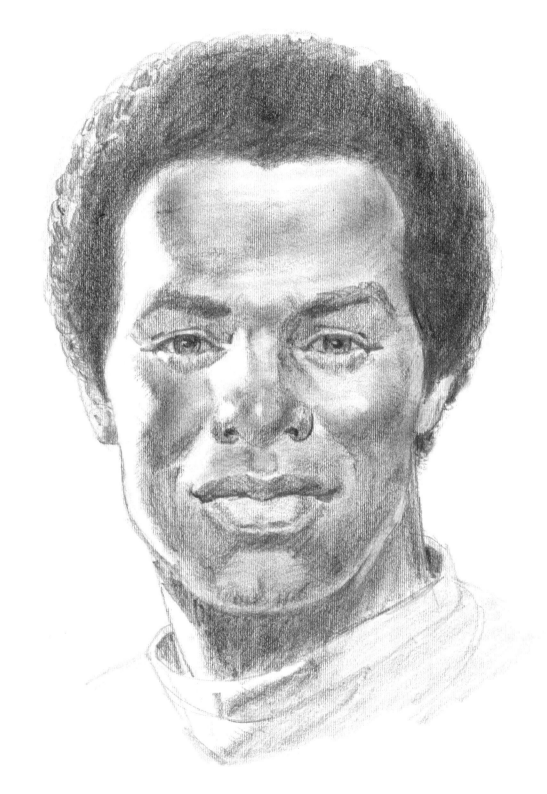

Step 7. The artist moves over the shadow areas with a fingertip, blending the strokes into smooth, glowing tones. The blending is done selectively: the artist concentrates mainly on the forehead, cheeks, nose, upper lip, and chin. A kneaded rubber eraser brightens the lighted areas and picks out highlights on the nose and cheek. The pencil strengthens the darks of the eye sockets and lids, the lips, the undersides of the cheeks, and the sides of the jaws. The tip of the pencil accentuates the contours of the eyelids, irises, and pupils; the nostrils; and the dark dividing line between the lips.

Step 1. Having discovered how easy it is to blend graphite on the hard surface of a sheet of textured paper, you know that a pencil drawing can actually begin to look like a "painting" in black and white. Now you might like to try a pencil portrait in which nearly all the tones are softly blended, so that the strokes of the pencil virtually disappear. For this drawing, the right tool is a thick, soft pencil—or perhaps a stick of graphite in a holder—that might be 4B, 5B, or even 6B. The artist chooses a 5B graphite lead in a plastic holder and works on a sheet of very rough paper with a much more pronounced tooth than the charcoal paper used in the preceding demonstration. He begins by drawing the usual compound egg shape and a tilted cylinder for the neck. The head is turned to a three-quarter view, and so the vertical center line is actually *off* center. Horizontal guidelines locate the features; the artist divides these lines with tiny touches to locate the eyes and the corners of the nose and mouth.

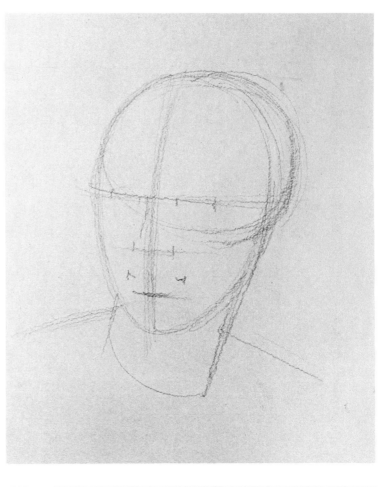

Step 2. The artist draws the outer contours of the face over the egg shape, capturing the curves of the cheeks, jaw, and chin. Swift, curving lines capture the sweep of the hair around the head and over the forehead. He draws the first few lines of the features over the guidelines of Step 1: the curves of the eyebrows and the upper lids; the side and underside of the nose; and the upper and lower lips. The one visible ear is aligned with the eye and nose. As you can see, the roughness of the paper breaks up the pencil stroke and produces a ragged line.

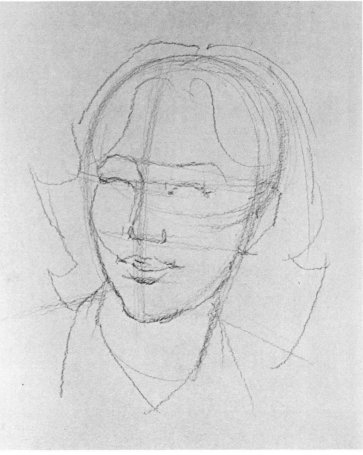

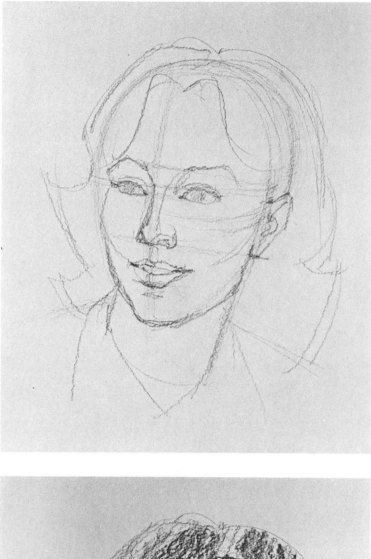

Step 3. The artist completes his preliminary line drawing of the outer contours of the head and the shapes of the features. He strengthens the lines of the jaw and the chin. He draws the ear more precisely and adds the inner contours of the eyes, with a hint of darkness on the irises. He traces the bridge of the nose and constructs the tip of the nose and the nostril wings. He indicates the groove from the base of the nose to the upper lip. As he defines the lips, he darkens the corners of the mouth and indicates the concavity beneath the lower lip with a dark scribble. The outline of the hair is strengthened with quick, casual lines.

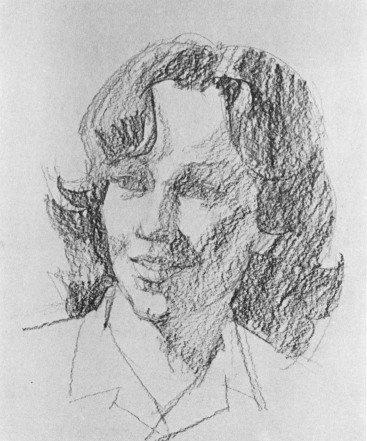

Step 4. Now the artist turns the thick lead on its side and moves it swiftly back and forth over the rough surface of the paper to indicate the big tonal areas. The paper is so rough that you can hardly see the individual strokes—the texture of the paper dominates the tones. The lines of Steps 1, 2, and 3 rapidly disappear under the ragged masses of tone. For the paler tones, the artist moves the drawing tool lightly over the paper, pressing harder and piling up additional strokes for the darker areas—such as the eye sockets, the cheeks, the shadow cast by the nose, and the hair. Most of the original lines have disappeared under the tones. The artist erases the others. The main purpose of Step 4 is to establish a clear distinction between the lights (which are just bare paper), the darks, and the middletones (or halftones).

Step 5. The artist begins to blend the tones of the face with a fingertip and with a stomp. He uses his finger to blend the broad tonal areas on the forehead, cheek, jaw, and neck. Then he picks up the pointed stomp to get into tighter spots like the eyes, the side and bottom of the nose, the lips, and the chin. The pencil darkens the eyes and lips a bit more—then the strokes are blended with the stomp once again. The artist softens the right edge of the hair with a few touches of a fingertip.

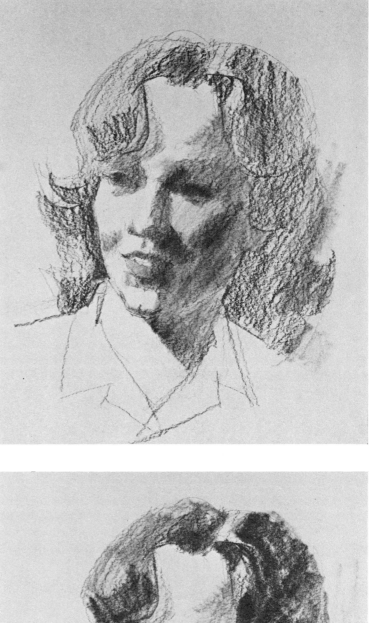

Step 6. At this stage, the artist alternates between working with the pencil and the stomp. He uses the pencil to define the eyebrows; to darken the eyes and the underside of the nose; and to strengthen the tones of the lips. Then he blends these tones with the sharp tip of the stomp. The side of the pencil scribbles broad strokes over the hair; then these strokes are blended with a fingertip. The sharp point of the pencil heightens the darks within the eyes, accentuates the nostrils, and sharpens the corners of the mouth. A few deft touches of the kneaded rubber eraser pick out reflected lights within the shadows on the cheek, jaw, neck, and ear—notice how the edges of these shapes become slightly lighter. The fingertip carries some tone downward to the pit of the neck, over one shoulder, and beneath the collar.

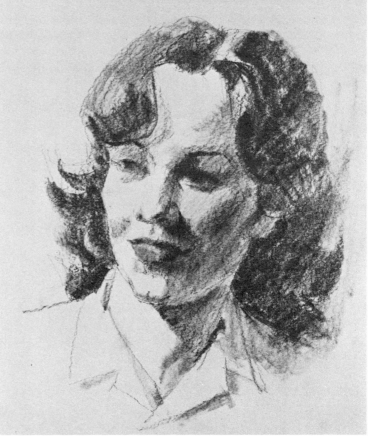

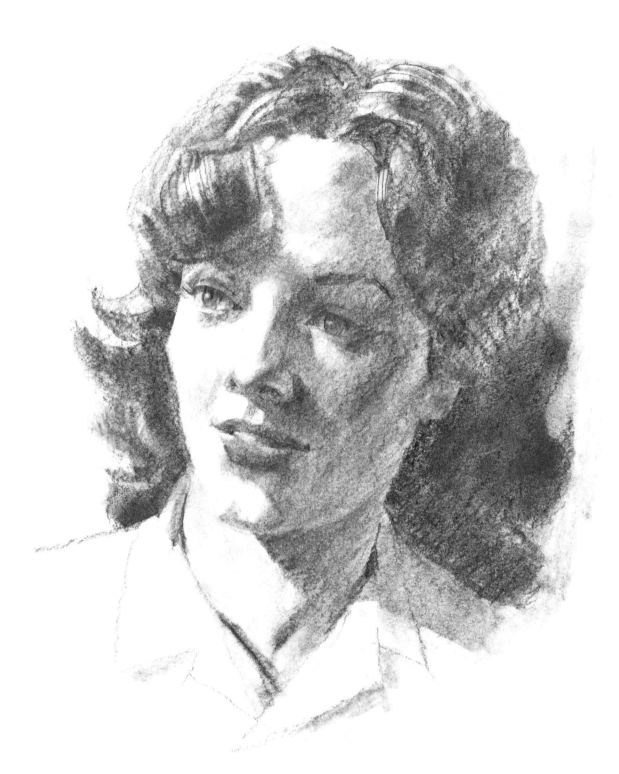

Step 7. The artist presses a fingertip against the sandpaper pad to pick up accumulated graphite dust, which he carefully spreads over the shadowy areas of the face and hair. The tones of the drawing become richer and deeper. The sharp tip of the pencil adds the details of the eyelids, irises, and pupils; draws the nostrils more exactly; strengthens the contours of the lips; and suggests individual strands of hair. Touches of the kneaded rubber eraser brighten the lighted areas of the face and pick out streaks of light in the hair.

Slender Strokes. A hard stick of chalk can be sharpened to a surprisingly fine tip. So can chalk in pencil form. With a sharpened stick or pencil, you can build up the tones of a portrait with slender strokes like those you see in this close-up. The precise strokes of the drawing tool follow the curve of the hair. The artist presses harder on the chalk and places the strokes closer together in the darker areas. The tones of the cheek and eyelid are rendered with clusters of short, curving parallel strokes. The sharp point of the drawing tool picks out the precise details of the eyes.

Broad Strokes. With the blunt end of the stick of chalk, you can draw the same subject with broad strokes. The square tip of the stick is used to make the thick, curving strokes that render the sitter's hair, as well as the clusters of short parallel strokes that model the eye socket, brow, and cheek. To render the more precise detail of the eyes, the artist simply turns the chalk so that the sharp corner of the rectangular stick touches the paper. This sharp corner can draw surprisingly precise lines, like those you see in the eyelids, irises, and pupils.

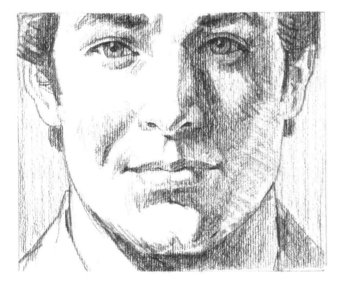

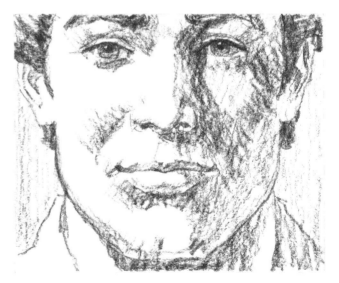

Strokes on Charcoal Paper. The ribbed surface of charcoal paper is excellent for chalk drawing, whether you're working with chalk in stick or pencil form. The charcoal paper softens the stroke and lends its own subtle texture to the drawing. Tiny flecks of bare paper show through the strokes and give the portrait a special kind of luminosity which you can't achieve on any other kind of paper. You can work with broad strokes like those you see on the cheeks. On the other hand, the paper is just smooth enough to lend itself to precise detail like the slender strokes of the features.

Strokes on Rough Paper. There are much rougher papers than charcoal paper, of course, and it's worthwhile to try these surfaces. A rough sheet is best for bold, broad strokes, made with the squarish end of the chalk. Notice how free and vital the strokes look on the cheeks and jaw. On the other hand, a reasonable amount of precision is possible on rough papers: the eyes are rendered with fairly precise, slender strokes, although these strokes are distinctly rougher than those with which the eyes are rendered on the charcoal paper at the left.

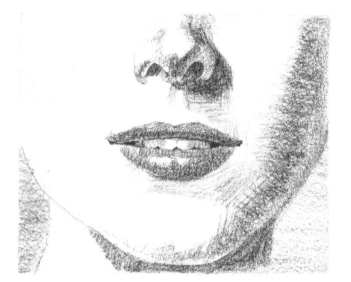

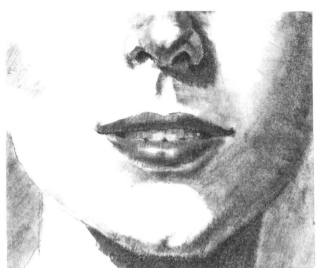

Modeling with Strokes. Working with a sharpened stick of chalk or with chalk in pencil form, you can build three-dimensional form by layering stroke over stroke. On the side of the face, the artist gradually lays one stroke over another, piling up strokes more thickly in the darker areas. The strokes curve slightly to suggest the roundness of the face. The lips and nose are also built up stroke over stroke. The network of strokes is dense in the dark areas, such as the shadow at the side of the nose, while the strokes are fewer and farther apart in the paler tones, such as the delicate gray beneath the lower lip.

Modeling by Blending. A different way to create a strong sense of three-dimensional form is to cover the tonal areas with free, casual strokes and then blend them with a fingertip or a paper stomp. The strokes don't have to be precise because they disappear as you blend them. The blending action converts the strokes to rich, smoky tones like those on the side of the sitter's face. If you blend some strokes, add darks with the chalk, and brighten the lighted areas with the kneaded rubber eraser, you can produce the strong contrast of light and shade that you see on the mouth and nose.

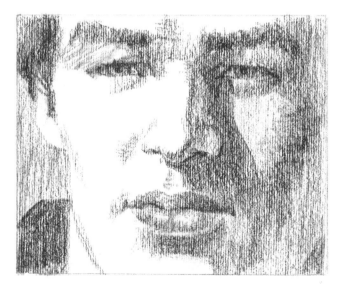

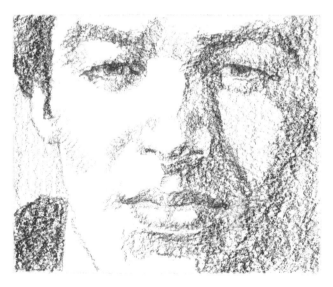

Continuous Tone on Charcoal Paper. Charcoal paper—like all strongly textured paper—has distinct peaks and valleys. As the chalk moves, it tends to strike the peaks and skip over the valleys. The peaks gradually shave away granules of chalk each time you make another stroke—and the tones become darker with successive strokes. Thus, you can build up soft, luminous tones by gently moving the chalk back and forth over the paper, pressing slightly harder and building up more strokes for the darks. Work slowly, and let the tones emerge gradually, and they'll have a unique inner glow.

Continuous Tone on Rough Paper. You can try the same technique on any paper that has a distinct tooth. On the rough sheet of paper shown here, a drawing of the same sitter has a bold, granular quality. Once again, the artist moves the chalk back and forth gradually so that it hits the peaks and skips over the valleys. With each successive movement of the chalk, more granules of chalk pile up and the darks become richer. It's almost impossible to see an individual stroke. The granular texture of the sheet dominates the drawing.

Step 1. When you draw your first portrait in chalk, see what you can do with just lines and strokes—no blending. A hard, fairly slender stick of chalk, such as a Conté crayon, is best for this project. The artist begins by sharpening the stick on a sandpaper pad so that the tool will make slender, distinct lines. He draws the classic egg shape. The portrait is a direct, frontal view, and so the vertical center line divides the face into equal halves. He draws the usual horizontal lines to locate the features—with a double line for the dividing line of the mouth and the underside of the lower lip. Just two vertical lines suggest the cylindrical form of the neck. The artist begins work on the features by placing the ears on either side of the egg, with the tops of the ears aligning with the eyebrows, and the lobes aligning with the underside of the nose.

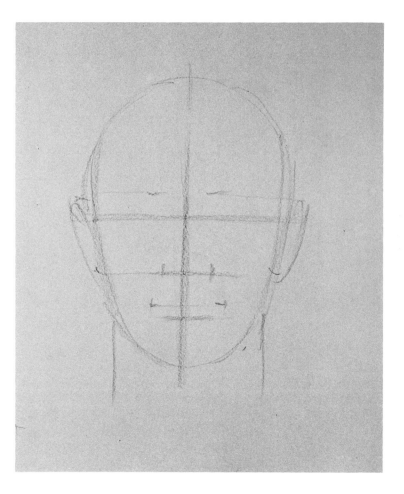

Step 2. Still working with the sharpened tip of the chalk, the artist begins to define the contours of the lower half of the face, starting with the curves of the cheeks and then working downward to the squarish jaw and the rounded chin. He swiftly sketches in the shape of the hair. He strengthens the lines of the neck and suggests the collar. Then he moves inside the egg to indicate the lines of the eyebrows and the upper lids; the bridge of the nose, the tip, and the nostrils; and the upper and lower lips. A scribble indicates the concavity beneath the lower lip. This concavity is always important because it accentuates the roundness of the lower lip.

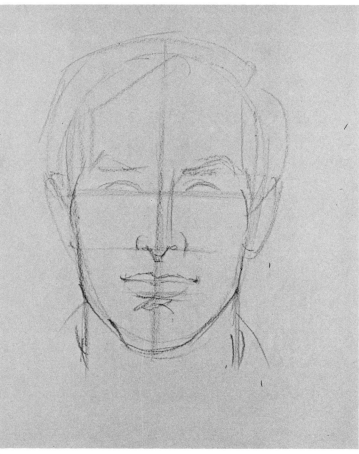

Step 3. By now, the point of the chalk has begun to wear away and the drawing tool is growing slightly blunt, making a thicker stroke. The artist strengthens the forms of the eyebrows and eyelids with thicker lines and then moves downward to solidify the forms of the nose and lips with strokes that are also broader than the slender lines in Steps 1 and 2. He refines the shapes of the ears. Then he uses the blunted point of the chalk to block in the shadow planes on the left side of the face and neck, within the eye sockets, and on the left sides of the features. Most of the face is lighted—the light comes from the right—and there are just slender strips of shadow on the left sides of the forms. Look back at the portrait of the black sitter, in which the effect is just the opposite: most of the face is in shadow with just slender strips of light on one edge of the face.

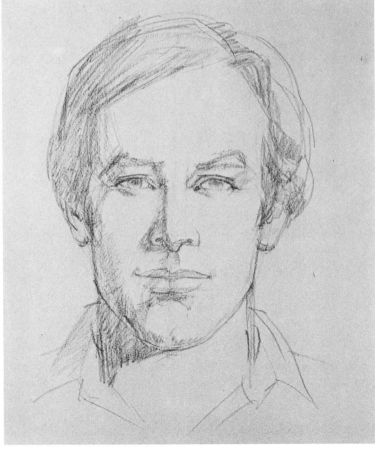

Step 4. The artist sharpens the stick once again to define the eyelids, the tip of the nose, the nostrils, and the contours of the lips with more exact lines. He also draws the contours of the hair more precisely and indicates the inner detail of the ears. A few lines suggest the collar. As the chalk grows blunt once again, he continues to build up the tonal areas with slightly thicker strokes. He blocks in the tones on the hair and begins to develop subtleties such as the groove between the tip of the nose and the upper lip, the cleft in the chin, and the shadows beneath the earlobes. The guidelines of Steps 1 and 2 have been erased.

Step 5. The blunted tip of the chalk is particularly useful at this stage. Now the artist moves back over all the tones with short parallel strokes, gradually building up the modeling. (These strokes are most obvious in the curve of the cheek.) We begin to see gradations *within* the tones, such as the light of the cheek curving around to the halftone, shadow, and reflected light on the other side of the shadow. Building up these strokes gradually, the artist darkens the eyebrows, the eye sockets, the nose, the shadowy upper lip, and the tone beneath the lower lip. He models the brow and the chin in the same way that he models the cheek and jaw. He builds up distinct shadow shapes within the hair and darkens the shadow on the neck. The sharp corner of the chalk adds dark touches within the eyelids and between the lips.

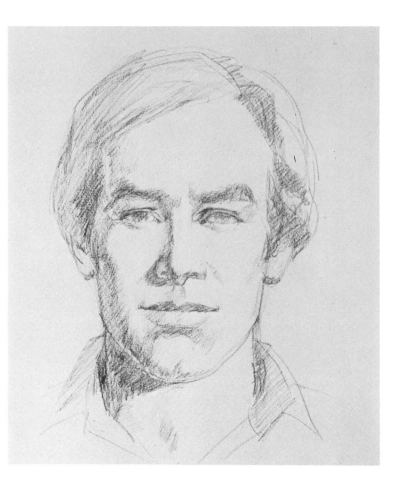

Step 6. Steadily piling stroke upon stroke, the artist continues to develop the tonal gradations of the brow, cheek, jaw, chin, and neck. He enriches the tones within the eye sockets and then moves downward to darken the side and the underside of the nose, the upper lip, and the pool of shadow beneath the lower lip. He darkens the earlobes, the central shadow in the ears, the nostrils, and the irises. The sharp corner of the chalk accentuates the eyebrows and suggests individual hairs. Turning the chalk around to work with the other end—which he hasn't sharpened—the artist follows the curves of the sitter's dark hair with broad strokes.

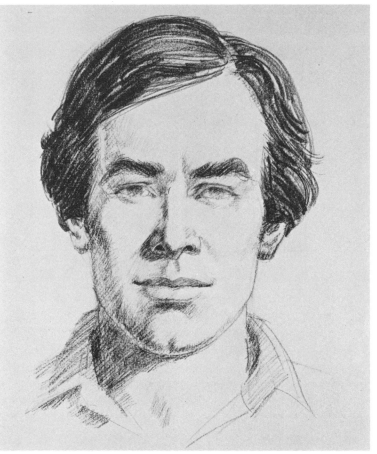

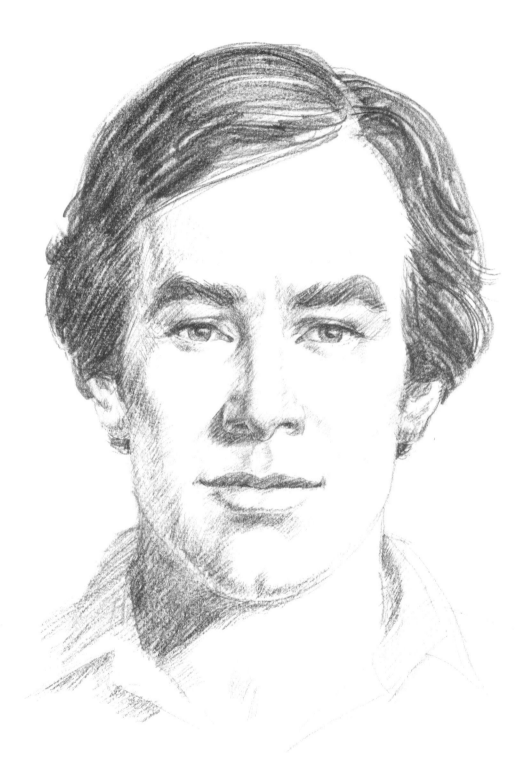

Step 7. The artist completes the portrait by building up the tones of the face with clusters of slender parallel strokes. The tones of the eye sockets, nose, lips, and ears are fully developed. He darkens the hair with a few more broad strokes, made with the unsharpened end of the stick. And, sharpening the stick once again, the artist moves back into the features, drawing the precise details of the eyelids, irises and pupils, nostrils, the winglike shape of the upper lip, and the softer, thicker form of the lower lip.

Step 1. To draw a portrait in which you combine slender lines, broader strokes, and blending, try a stick of hard pastel. A sheet of rough-textured paper will lend itself especially well to blending with a fingertip or a stomp. The artist begins by sharpening a stick of hard pastel on the sandpaper pad. The stick doesn't come to as sharp a point as a pencil, of course, but he's able to draw distinct lines with it. Notice how the rough texture of the paper breaks up the lines of the compound egg shape. Because the model is turned to a three-quarter view, the vertical center line moves to the left of the egg. However, the horizontal guidelines of the eyes, nose, and mouth are in their usual places. On these horizontal lines, the artist makes tiny marks to locate the eyes, nostrils, and corners of the mouth. At the extreme right of the head, he makes two small horizontal marks to align the ears with the eyebrows and the underside of the nose. As usual, the neck is a slanted cylinder.

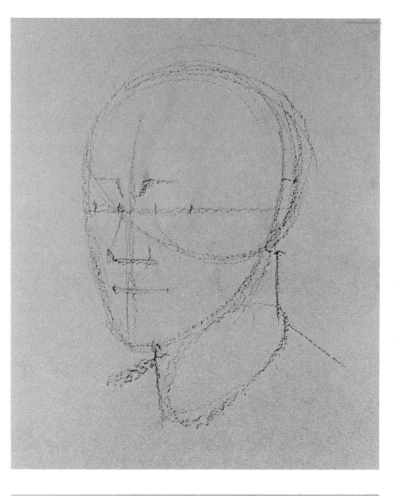

Step 2. By this time, the sharpened stick of hard pastel is growing slightly blunt, and so the artist sharpens it again on the sandpaper pad. Then he draws the angular contours of the head—the brow, cheeks, jaw, chin, and neck—over the guidelines of Step 1. With just a few curving lines, he indicates the shape of the hair, which crosses the forehead and extends above the curve of the skull. He begins to draw the features over the familiar guidelines and completes this stage by suggesting the triangular shape of the collar.

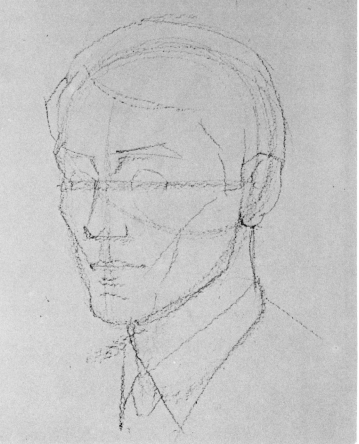

Step 3. Erasing the guidelines of Step 1, the artist begins to define the features more precisely. He draws the slender eyelids and constructs the blocky end of the nose—with the one nostril wing that shows in this three-quarter view. Now you see the familiar winglike shape of the upper lip. The artist adds a curve just above the chin to define the bony shape. He squares up the corner of the jaw and then moves upward to draw the internal detail of the ear. On the hard surface of the paper, chalk sometimes smudges or even disappears; this has happened to the line of the jaw just to the left of the mouth. But the line can be easily redrawn in the next step.

Step 4. The rectangular stick of hard pastel is still fairly sharp, and so now the artist blocks in the tonal areas with clusters of parallel strokes. Notice how the strokes change direction as they move downward from the brow to the cheek to the jaw, following the direction of the form. The tone on the slanted side of the nose is rendered with slanted lines. The artist fills the eye socket with tone; places the shadow beneath the nose; fills the upper lip with shadow; and indicates the deep shadow beneath the lower lip. With the flat side of the stick, he blocks in the tonal areas on the hair. Then, sharpening the stick once again, he adds more detail to the eyes and ear.

Step 5. Moving a fingertip gently over the surface of the drawing, the artist blends the strokes of Step 4 selectively. He gradually blurs the tones on the side of the brow, cheek, jaw, and neck, but doesn't eliminate *all* the strokes. You can still see some of them. In the same way, he gently merges the strokes within the eye sockets, along the side of the nose, and beneath the nose and lower lip. A few broad sweeps of the thumb convert the strokes of the hair into tone. The sharp point of a stomp gets into smaller areas such as the eyebrows and eyes in order to fuse the strokes. Turning the stick of hard pastel to the opposite end and working with the flat tip, the artist adds dark strokes to the hair, eyebrows, eyes, cheek, and jaw, sometimes blending them with a fingertip and sometimes leaving them alone. With the side of the chalk, he adds a dark tone above the head and then blends this with his thumb.

Step 6. The sharpened end of the chalk defines the outer contours of the face more precisely; compare the cheek with Step 5. The artist then draws the eyelids more exactly, adding the pupils and the dark accents at the corners of the eyes. He defines the nostrils and the shape of the upper lip, darkening the corners of the mouth. He adds more darks within the ear. Then he continues to strengthen the darks by adding clusters of short parallel strokes to the eye sockets, the tip of the nose, the brow, and the cheek, blending these with a fingertip or a paper stomp. The side of the chalk darkens the hair and shoulders with broad strokes, which are quickly blended with the thumb.

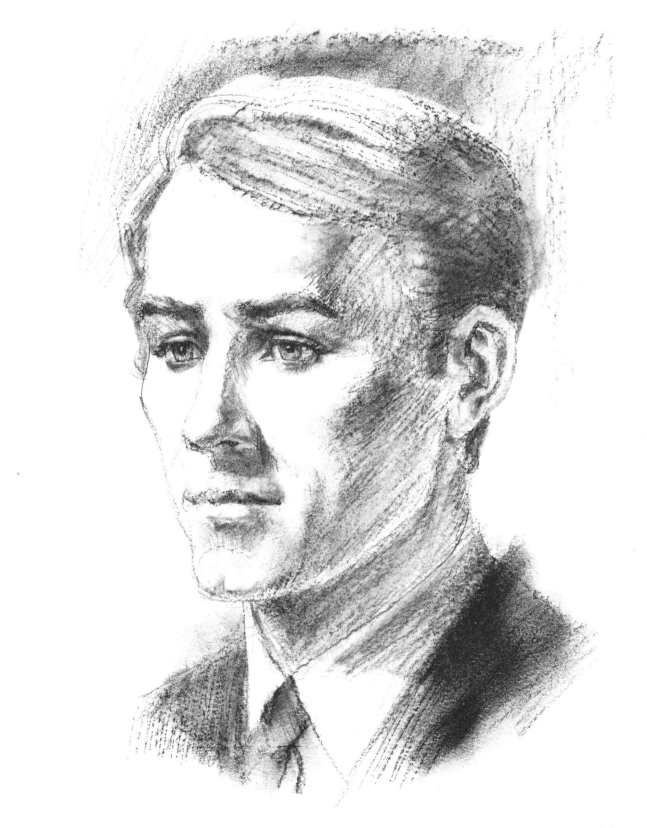

Step 7. The artist presses his fingertip against the sandpaper pad, picks up some chalk dust, and gently spreads this tone over the shadow planes of the face: the forehead, cheek, jaw, neck, eye sockets, nose, and lips. In the same way, he adds tone to the neck, hair, ear, and collar. The point of the chalk darkens the contours of the eyelids, plus the tones of the eyebrows and lips. A kneaded eraser brightens the lighted patches, and a razor blade scratches highlights into the eyes.

Step 1. Chalk smudges so easily that you can blend it like wet oil paint. Now try a portrait that consists almost entirely of soft, blended tones. The artist draws this portrait of an Oriental woman with a stick of hard pastel on a sheet of charcoal paper. This type of paper has a hard, delicately textured surface on which chalk can be blended very smoothly. The tough surface will take a lot of rubbing from a fingertip, a stomp, or an eraser. By now, Step 1 is familiar: the classic egg shape, cylindrical neck, and vertical and horizontal guidelines to locate the features. However, as you look back at the various demonstrations you've seen so far, notice that not all the egg shapes are exactly alike. There are subtle differences in height and width. Some are tall and relatively slender, while others are rounder, like the soft form of this woman's face.

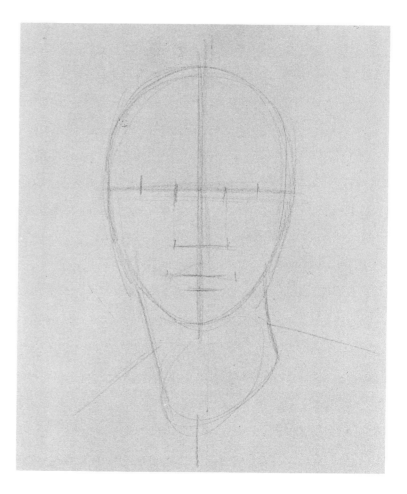

Step 2. Over the guidelines of Step 1, the artist constructs the actual shape of the head and hair. He defines the curves of the cheeks, the squarish shapes of the jaw, and the rounded chin. With long, curving lines, he draws the sweep of the hair that surrounds the entire head and neck. A few slanted lines suggest the collar. The features are hung on the horizontal guidelines within the egg. Notice that he indicates not only the eyes, but also the inside corners of the eye sockets on either side of the nose. The lines in Steps 1 and 2 are executed with the sharp corner of the rectangular stick of chalk. As one corner wears down, the artist turns the chalk in his hand and uses the next corner. The corners stay sharp just long enough to execute the preliminary line drawing.

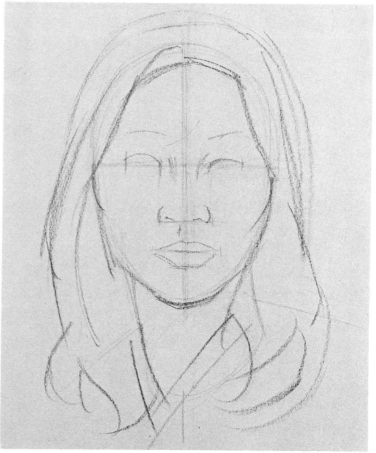

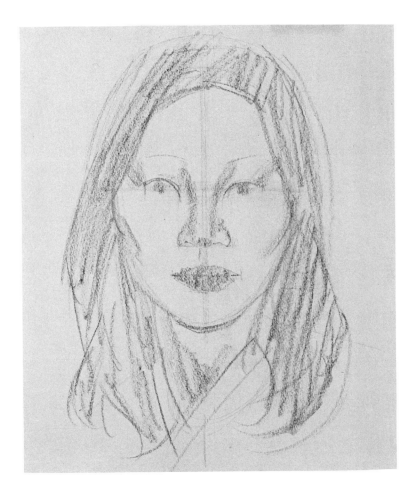

Step 3. The artist uses the square end of the chalk to block in tones with broad strokes. A single curving stroke is placed on either side of the nose. A few more short strokes suggest the shadows around the nostrils and beneath the tip of the nose. Short, broad strokes place the shadows in the outside corners of the eyes, along the cheeks and jaw, and at the pit of the neck. The lips are filled with tone. The dark irises are made with quick touches of the blunt end of the chalk. And then the hair is filled with long, free strokes to indicate the dark tone. At this stage, the chalk glides lightly over the surface of the paper, merely indicating tonal areas that will be developed in later steps.

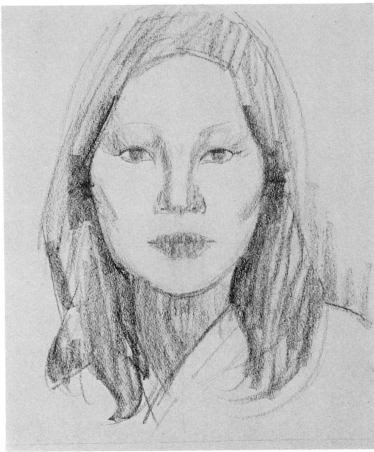

Step 4. Pressing harder on the square end of the chalk, the artist darkens the irises and extends the shadows on either side of the nose. Then, with the sharp corner of the stick, he draws the dark lines of the eyelids and the nostrils. Moving the blunt end of the stick lightly over the paper, he gradually darkens the tones within the eye sockets. He picks up a short chunk of chalk—perhaps a broken stick or simply one that's worn down—to darken the hair and neck with broad strokes. He uses the flat side of the stick and presses down harder against the paper.

Step 5. Moving a fingertip gently over the paper, the artist begins to smudge the strokes within the eye sockets, beneath the nose, and along the sides of the cheeks. With a kneaded eraser, he lightens the shadows on either side of the nose. He blends the strokes on the neck, blurring the line of the chin. With the flat side of the short chunk of chalk, he darkens the hair and blends this area with his thumb, carrying some of the hair tone into the shadows beneath the cheeks. He blends the lips very slightly. Then he uses the sharp corner of the chalk to redefine the eyebrows, eyes, nostrils, and lips, softening these strokes with a quick touch of a fingertip.

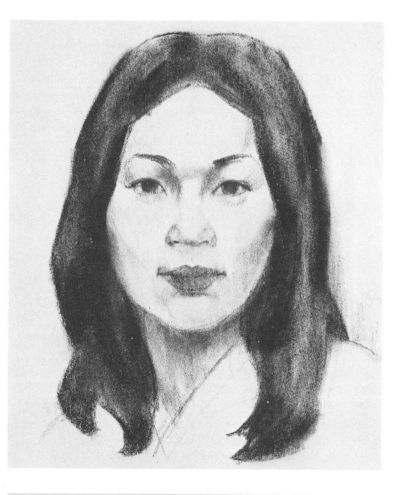

Step 6. The artist's thumb and one or two fingers are now coated with chalk dust. He uses his fingers like a brush to spread tones on the sides of the forehead, beneath the cheeks, along the sides of the jaw, and on the neck, which grows distinctly darker than in Step 5. The finger places very pale tones on either side of the nose and darkens the corners of the eye sockets. Then the sharp corner of the chalk restates the eyebrows, eyelids, nostrils, and lips. Small, precise strokes add pupils to the eyes, sharpen the nostrils, and define the dark corners of the mouth. The flat side of the short chalk sweeps over the hair with long, broad strokes. A kneaded eraser is squeezed to a point to pick out highlights on the pupils, brighten the whites of the eyes, clean the edges of the lips, and create highlights on the lower lip.

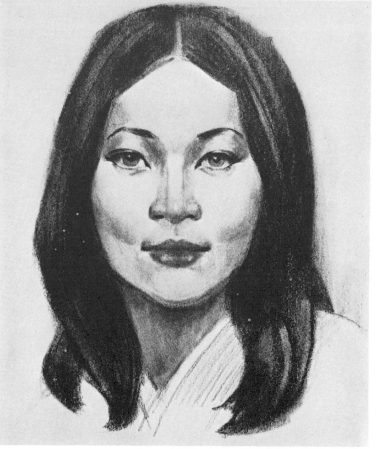

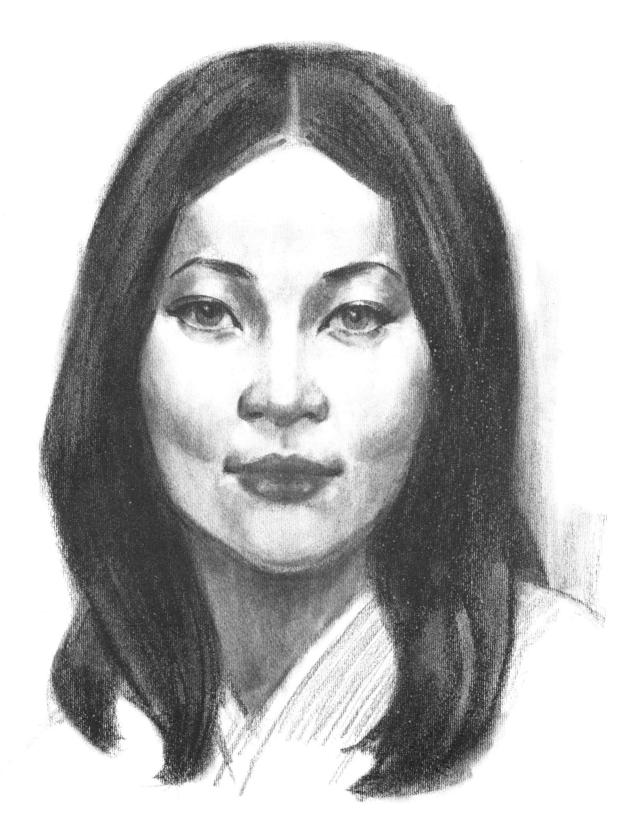

Step 7. The artist blends the tone of the hair with his fingertips, blurring the contours and adding a few strokes to suggest detail. His fingers are coated with chalk dust, which he carefully spreads over the face to add delicate halftones to the forehead, cheeks, and jaw, and to darken the neck and the underside of the nose. The kneaded rubber eraser brightens the lighted areas of the forehead, eye sockets, cheeks, nose, upper lip, and chin. The sharp corner of the chalk strengthens the upper eyelids and adds a few eyelashes.

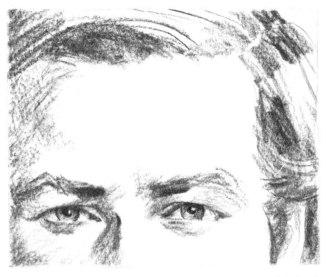

Slender Strokes. A hard or medium charcoal pencil can be sharpened to a fairly precise point to make crisp strokes. The tones of the sitter's hair, forehead, and eyes are built up with clusters of parallel strokes made by the sharp point. The artist builds one cluster of strokes over another to darken the tones within the eye sockets, beneath the eyes, and along the side of the nose. The slender strokes in the hair are made by the point of the pencil, while the broader strokes are made by the side of the lead.

Broad Strokes. A soft charcoal pencil has a thick lead that's suitable for a broad-stroke technique. So does a stick of charcoal—in your hand or in a holder. Compare the wider, rougher strokes in this drawing with the more precise strokes in the drawing at the left. The soft charcoal pencil or the charcoal stick *can* be sharpened to do a certain amount of precise work—such as the slender strokes in the hair and within the eyes—but the point wears down quickly. Artists generally work with the side of the soft pencil or the stick to cover broad areas.

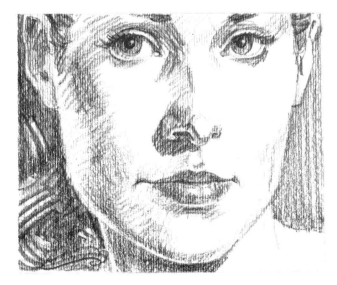

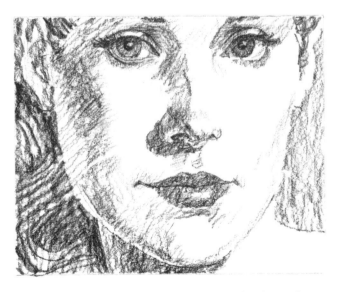

Strokes on Charcoal Paper. The strokes of the hard and medium charcoal pencils are particularly effective on charcoal paper, as you might expect. The ribbed texture of the sheet softens the strokes, which are filled with pinpoints of bare paper. Look at the tones on the side of the nose and cheek, the shadow beneath the nose, and the dark tone of the lips—they seem transparent and filled with inner light. The tiny flecks of bare paper make even the darkest tone look luminous.

Strokes on Rough Paper. The strokes of a charcoal pencil or a stick of charcoal look lively and spontaneous on paper with a ragged texture. The granular texture of the charcoal is accentuated by the coarse surface. The strokes in this portrait are bolder—though less distinct—than the more sharply defined strokes in the drawing at your left. It's worthwhile to try rough paper because it encourages you to work with bold, free strokes. And you have to keep the drawing simple, since you can't build up too much detail.

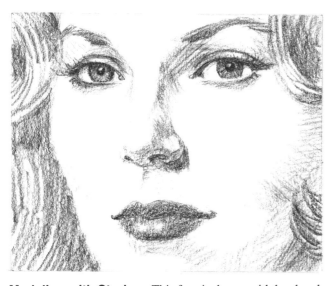

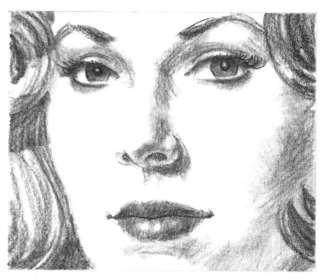

Modeling with Strokes. This face is drawn with hard and medium charcoal pencils. The artist builds up his strokes in clusters which change direction as the form curves. Notice how the strokes wrap around the corners of the eye sockets and slant diagonally down the side of the nose. The groups of strokes gradually change direction as they move around the sides of the cheeks. Don't just dive in and start scribbling! *Plan* your strokes.

Modeling by Blending. A medium charcoal pencil blends easily, while a soft pencil or stick of natural charcoal blends still *more* easily. In this drawing of the same sitter, the artist blocks in the tones with broad, casual strokes and then smudges them with a fingertip to form soft, velvety tones. He doesn't blend the strokes so thoroughly that they disappear, but allows some of them to show through the blurred tones. You can see this most clearly on the cheek, within the eye sockets, and along the side of the nose, where the underlying strokes add solidity to the soft, misty veils of tone.

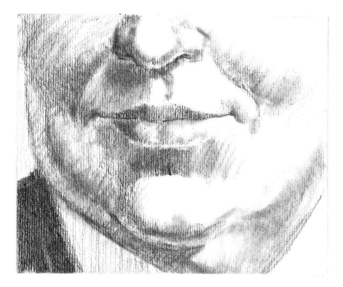

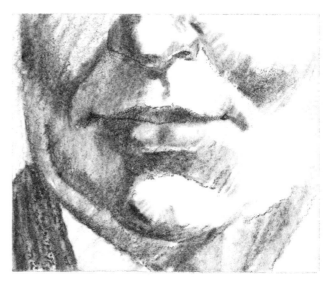

Strokes and Blending on Charcoal Paper. The hard surface of charcoal paper is ideal for a technique that combines slender lines like those along the bottom of the nose and between the lips; broad strokes like the ones on the shadow side of the face; and blended areas, which you see throughout this close-up of a male portrait. The artist uses a sharply pointed hard charcoal pencil for the precise lines and edges in this drawing, switching to a soft pencil for the broad strokes and then blending the tones with a stomp.

Strokes and Blending on Rough Paper. The granular strokes of a stick of natural charcoal look particularly effective on the ragged surface of a sheet of rough drawing paper. The textures of the paper and the strokes seem to match. When the strokes are blended, natural charcoal behaves like wet oil paint, which you can spread easily over the surface with a fingertip or a stomp. And you can use a sandpaper pad to make the stick just sharp enough to draw lines like those you see on the nose and between the lips.

Step 1. Like graphite pencil and chalk, charcoal handles beautifully on any sturdy white drawing paper that has a moderate amount of texture—just enough to shave off the granules of charcoal as you move the drawing tool across the surface of the sheet. Charcoal blends so easily that it's always tempting to smudge the tones of a charcoal drawing; but resist this temptation and begin with a portrait in which you render the tones entirely with strokes. In this portrait, the artist uses a combination of three charcoal pencils: hard, medium, and soft. He begins with the hard pencil, sharpened to a point, for the preliminary sketch of the compound egg shape, with its vertical and horizontal guidelines. The head is turned to the right, and so the center line moves to the right too. Since the sitter's head is tilted slightly downward, the horizontal lines curve gently around the egg. The artist follows these curves to locate the ear, which seems a little high on the head but actually aligns with the curving guidelines of the eyes and nose.

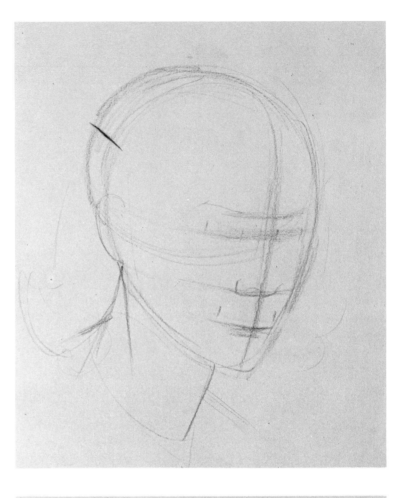

Step 2. The hard charcoal pencil draws the contours of the head and hair with pale lines—the artist doesn't press too hard. The eyebrows, eyes, nose, and mouth are carefully placed on the curving guidelines of Step 1. Because the head tilts slightly downward, the hairline seems to come farther down the forehead and we see more of the top of the head. Curving lines wrap the shape of the hair around the top of the egg and bring the hair down around the sides of the face. Even at this early stage, the upper lip begins to have its characteristic double-wing shape. When the head is turned to a three-quarter view, the vertical center line is particularly important in helping you line up the bridge and underside of the nose, the groove between the nose and upper lip, the center of the lips, and the midpoint of the chin. In this view, the eye at the right is close to the center line, while the eye at the left is farther away.

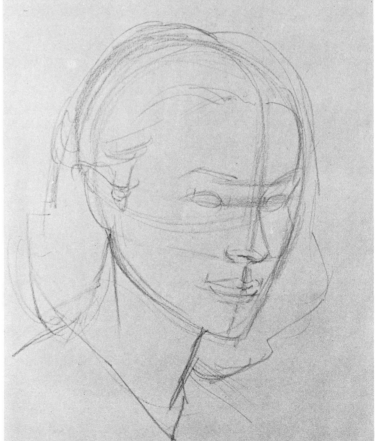

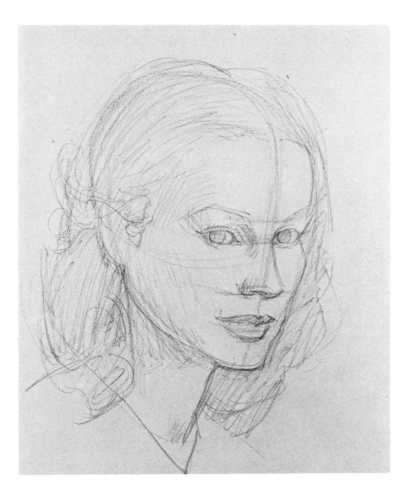

Step 3. The point of the hard charcoal pencil lasts longer than the point on a medium or soft pencil, and so the artist continues to work with it to draw the precise shapes of the eyes, nose, mouth, cheeks, jaw, and chin. Now you can see both lids, the concave corner of one eye socket, the exact shape of the nostril, the winglike shape of the upper lip, and the full, squarish lower lip. Having defined the features, the artist scribbles the point of the hard pencil lightly over the tonal areas of the head: the hair, forehead, cheek, jaw, neck, eye sockets, nose, and lips. By the end of Step 3, he's established a clear distinction between the light and shadow areas of the head.

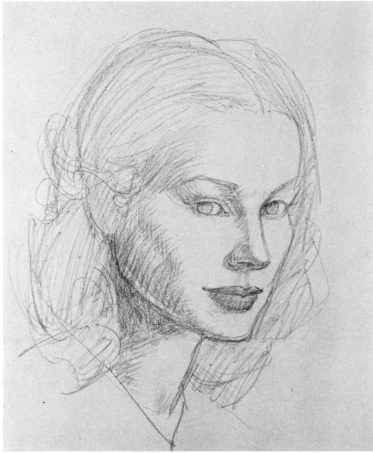

Step 4. Switching to a medium charcoal pencil, the artist starts to build up the tones on the forehead, cheek, jaw, neck, eye sockets, nose, and lips. Notice how he swings the pencil in a short arc so that the strokes match the curves of the sitter's face. These curved strokes are most apparent on the forehead, cheek, and jaw, but there are also smaller ones within the eye sockets and along the side of the nose. Notice how the dark hollow within the cheek is suggested by a second row of slanted strokes that overlap the first cluster. When one cluster of strokes crosses another at an angle—as you see here— this technique is called *hatching*. The sharp point of the medium charcoal pencil strengthens the contours of the eyes, adding a delicate tone beneath the upper lid to suggest the shadow that the lid casts on the eye. The point of the pencil also defines the shape of the lips.

Step 5. Turning the medium charcoal lead on its side, the artist continues to build up the tones with broad, curving strokes. Once again, he goes over the side of the forehead, cheek, jaw, and neck, darkening and solidifying the tones of Steps 3 and 4. (Notice how much broader the strokes are becoming at this stage.) He deepens the tones within the eye sockets and along the underside of the nose. He accentuates the shadow lines around the eyelids and adds the internal detail of the ear. With big, free movements, he darkens the hair by scribbling the pencil back and forth with curving strokes to suggest the texture of the sitter's curls. Where the dark hair silhouettes the lighted side of the face, he strengthens the line of the brow, cheek, jaw, and chin. The head now looks far more three-dimensional than it did in Step 4.

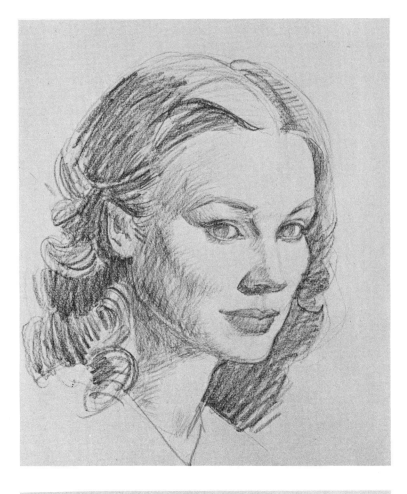

Step 6. The soft charcoal pencil makes a much darker, broader stroke than the hard and medium pencils the artist has used so far. Now he uses a soft pencil to darken the curls of the sitter's hair with clusters of short, thick strokes. Now there's a much stronger contrast between the pale tones of the face and the surrounding darks. The soft pencil is just sharp enough to darken the eyebrows, eyes, nostrils, and the shadow beneath the nose. Notice the hint of shadow beneath the upper eyelids.

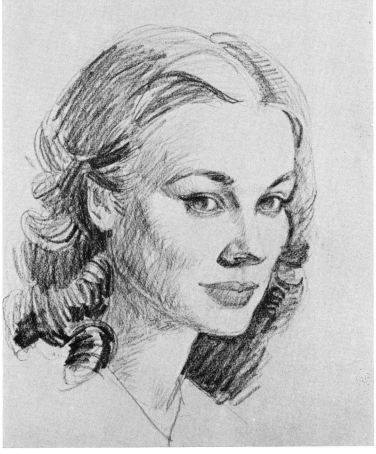

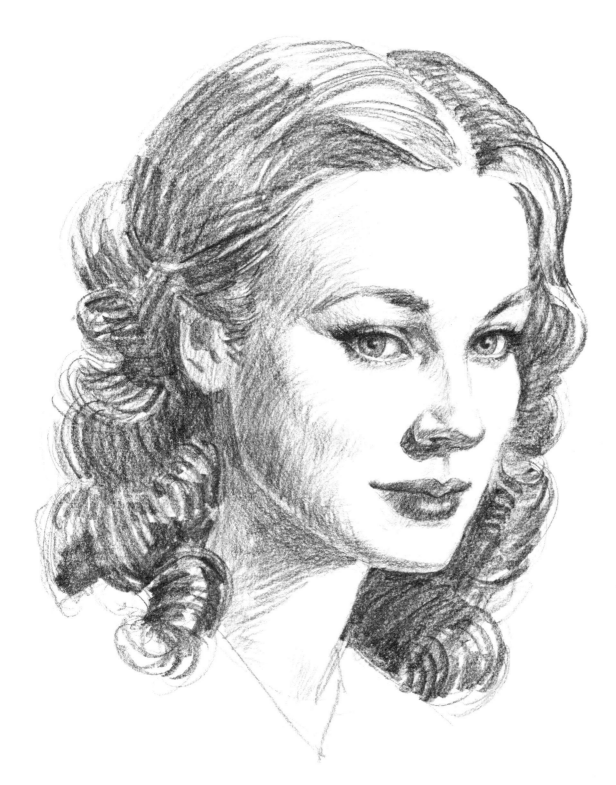

Step 7. The artist darkens the hair with broad, curving strokes of the soft charcoal pencil. The pencil moves over the face to deepen the shadows on the forehead, cheek, jaw, and neck, and to darken the eye sockets, lips, and the tones that surround the nose. The artist focuses on the eyes again, darkening the lines of the eyelids, adding pupils, and suggesting lashes. A kneaded eraser brightens the whites of the eyes, picks out highlights on the pupils, adds touches of light on the lids, and then carefully cleans the lighted areas on the face.

Step 1. To demonstrate a technique that combines strokes with blended tones, the artist chooses an interesting trio of drawing tools. He works with a medium charcoal pencil and two sticks of compressed charcoal, one medium and one soft. Compressed charcoal is made of crushed charcoal granules that have been bonded together under pressure to make a stick that behaves somewhat like hard pastel—in contrast with natural charcoal, which is literally a charred twig. Compressed charcoal makes a more precise stroke that doesn't smudge quite as easily as the natural variety. The artist draws his preliminary guidelines with the medium charcoal pencil on a sheet of charcoal paper, a surface on which blending is particularly effective.

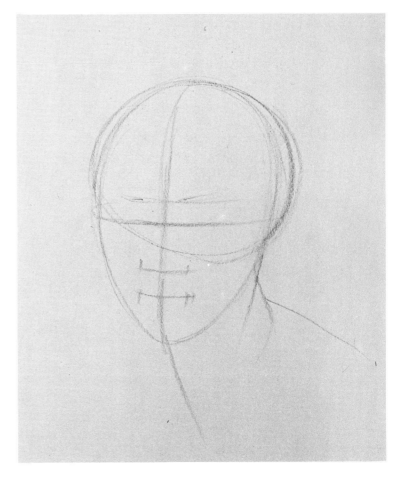

Step 2. The charcoal pencil begins to draw the contours of the face over the guidelines of Step 1. The artist places the features on the horizontal guidelines, aligning the ears with the eyes and nose. He surrounds the head with the circular contour of the sitter's hair. The ribbed surface of the charcoal paper is already apparent at this stage. Since the drawing will be dominated by broad strokes and smudged tones, the artist doesn't want the preliminary lines to be sharp and wiry; the charcoal paper softens the lines so they'll melt away into the tones of the completed drawing.

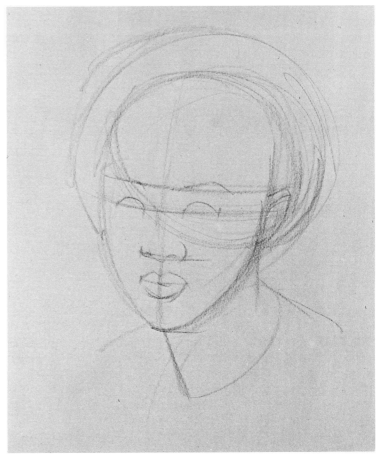

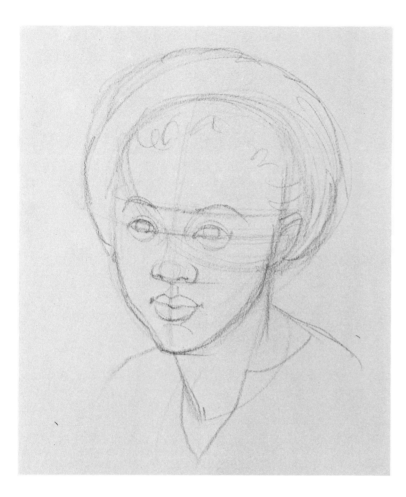

Step 3. The artist develops the curves of the sitter's cheeks, jaw, and chin with the pencil. Then he defines the rounded shapes of the features more exactly. You see the curves of the eyebrows and eyelids,, the rounded shapes of the nostrils and the tip of the nose, and the full, sculptural lips. This is the last time we'll see the guidelines of Step 1, which are erased after the completion of Step 3.

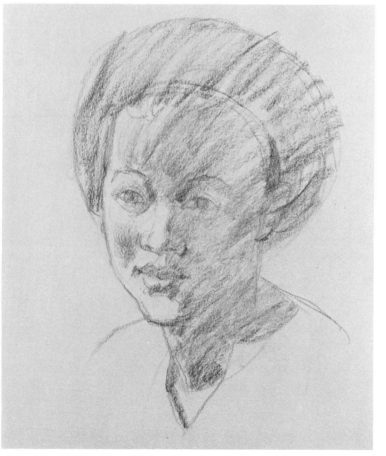

Step 4. Picking up the medium stick of compressed charcoal, the artist blunts the stick on the sandpaper pad so that it will make broad strokes when he holds it at an angle to the paper. Then the artist sweeps the tool diagonally across the drawing, filling the hair and face with thick, irregular strokes. Moving around the features, he darkens the eye sockets, eyes, nose, and lips with broad strokes. At this stage, the thick compressed charcoal moves very lightly over the paper, since the artist's purpose is simply to establish the major areas of light and shadow. Although at this stage the drawing is quite pale, the artist has already recorded the dramatic lighting.

Step 5. Moving his thumb firmly over the drawing—since compressed charcoal needs some pressure to blend—the artist softens and fuses the strokes of Step 4 on the forehead, within the eye sockets, on the cheeks and jaw, and on the neck and shoulder. Picking up the medium charcoal stick again, he darkens the hair with scribbly strokes that begin to suggest the texture of the sitter's curls. The blunt charcoal stick darkens the forehead; adds more tone to the eye sockets; accentuates the irises and the shadows beneath the eyes; builds up the tones around the nose and lips; and adds stronger darks to the side of the face, neck, and shoulder. The lighter side of the cheek is dramatized by a touch of darkness on the left.

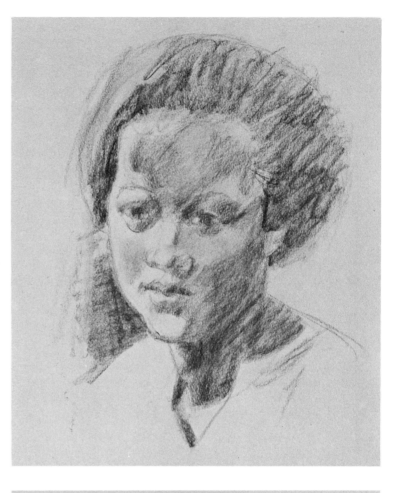

Step 6. Now the artist reaches for the soft stick of compressed charcoal to intensify the darks throughout the drawing. He presses hard on the stick to enrich the hair with short, curving strokes. He darkens the tones around the features with broad strokes and then blends them with a stomp, which gets into these tight spots more easily than a fingertip. Sharpening the compressed charcoal stick—which holds a point better than a stick of natural charcoal—he adds crisp, dark strokes to the eyebrows, eyes, nostrils, and lips. So far, the features have all been soft and indistinct; now they come into sharp focus. Broad strokes darken the cheek and the shadow beneath the chin, and the artist blends them with a fingertip.

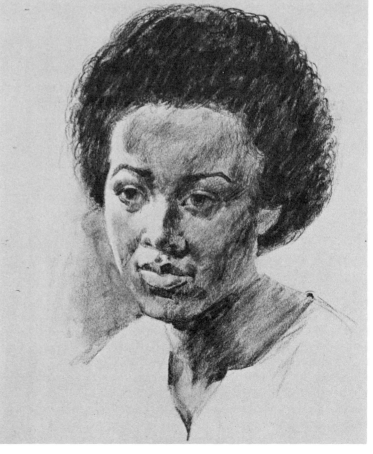

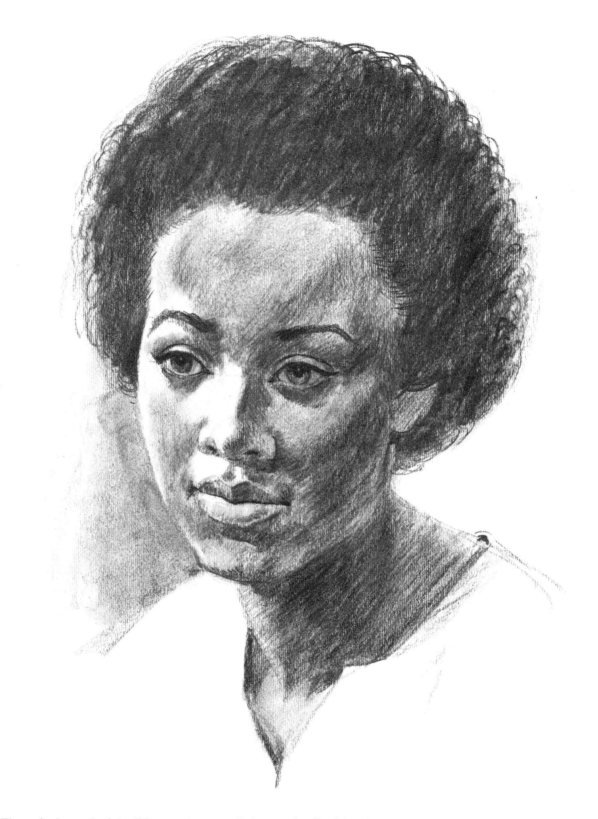

Step 7. The soft charcoal stick glides gently over all the tonal areas of the face, making broad, soft strokes that you can see most clearly in the cheek, jaw, and neck. The artist blends these strokes with his thumb, slowly building up the dramatic effect of light and shade. Thick strokes are added to the hair and partially blended with the thumb, allowing the strokes to remain distinct enough to communicate the detail of the sitter's hair. The point of the charcoal stick strengthens the edges of the features with sharp lines that heighten the contours of the eyelids, nostrils, and lips. A wad of kneaded rubber cleans the lighted areas of the face. The finished drawing retains the vitality of the bold strokes, which the artist blends but never eradicates.

Step 1. The ancient stick of natural charcoal—which is just a twig that's been heated until it turns black—is one of humankind's most miraculous drawing instruments. That black, crumbly twig delivers an extraordinary range of smoky tones that you can blend with a fingertip to "paint" a black-and-white portrait as rich and subtle as any oil painting. For this final demonstration, the artist chooses an extremely rough sheet of paper with a hard, ragged surface that's excellent for blending. Sharpening a stick of natural charcoal on a sandpaper pad, the artist draws a compound egg shape that is turned to a three-quarter view. You see the usual guidelines. The lines made by the charcoal stick are rough and bold, but they'll quickly disappear with a mere touch of the fingertip as the artist begins to blend his tones.

Step 2. A natural charcoal stick is never quite as sharp as a charcoal pencil, so the lines always have a broad, irregular quality—which is part of their beauty. The artist begins to draw the contours of the head with quick, rhythmic strokes, letting the stick coast lightly over the rough surface of the paper. The lines aren't neat and precise, but they're full of vitality. The artist doesn't draw too carefully, since these lines will melt away when he begins to blend the tones in later steps. Notice how the irregular surface of the paper breaks up the lines.

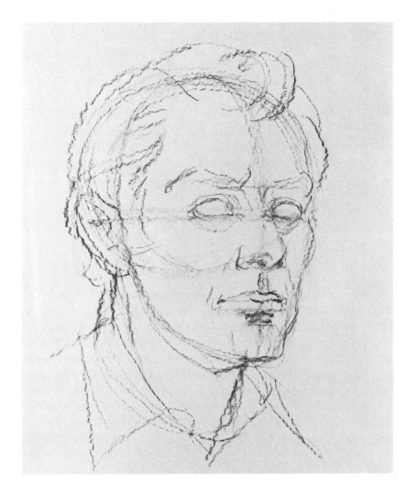

Step 3. The line drawing of the face and features is completed. Although the lines are granular and broken, the artist defines the shapes of the eyelids, nose, lips, and ear. He reshapes the contours of the cheeks, jaw, and chin. He develops the distinctive shape of the hair and suggests the collar with just a few strokes. Aside from establishing a reasonable likeness, the purpose of this line drawing is to provide a guide for the big masses of tone that will come next—and bury the lines!

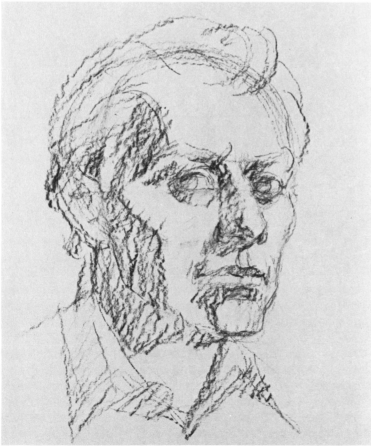

Step 4. Holding the charcoal stick at an angle to the paper, the artist blocks in the big masses of tone with broad, irregular strokes. He works swiftly and decisively, leaving big gaps between the strokes. The gaps don't matter because the strokes will soon be blended to form smooth tones. The head suddenly becomes boldly three-dimensional as the artist places big shadows on the side planes of the brow, cheek, jaw, neck, eyes, nose, and chin. The upper lip turns away from the light into darkness. The nose casts a shadow downward toward the upper lip. And there are jagged shadows within the collar. Even at this early stage, the drawing has the simplicity and power which are unique to natural charcoal. The artist *could* stop here, but he goes on because the purpose of this demonstration is to show the rich tonal possibilities of the medium.

Step 5. The artist lets his fingertip glide lightly over the tonal areas of Step 4, gently fusing the rough strokes into soft, smoky tones. Suddenly, we have a totally new drawing! The lines and strokes of the first four steps have practically disappeared as the artist transforms them into subtle shades of gray. Then the charcoal stick moves back over the smoky tones to sharpen certain details, such as the inner shapes of the ear, the corners of the eyes, the underside of the nose, the square contour of the jaw, and the shapes of the lips.

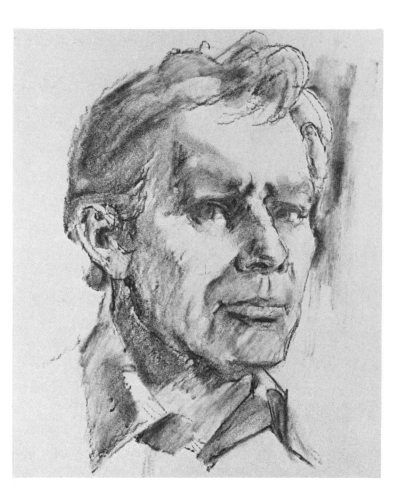

Step 6. Now the artist keeps switching back and forth between the charcoal stick and his fingertip. Short, thick strokes darken the eyebrows, eye sockets, nose, lips, cheek, and chin. The artist blends these strokes very gently with a fingertip—or with a stomp when the area is too small for his fingertip. The technique is to make a few strokes and blend them, and then make a few more strokes and blend them, gradually building up the tones and accentuating the details. Sharpening the stick on a sandpaper pad, the artist draws crisp lines within the eyes, blackens the pupils, and deftly picks out highlights within the pupils with the sharp corner of a razor blade. Dark, slender lines redefine the shapes of the nose and chin. The artist strengthens the corners of the mouth and adds a few wisps of hair over the ear. He adds detail very selectively, without overdoing it.

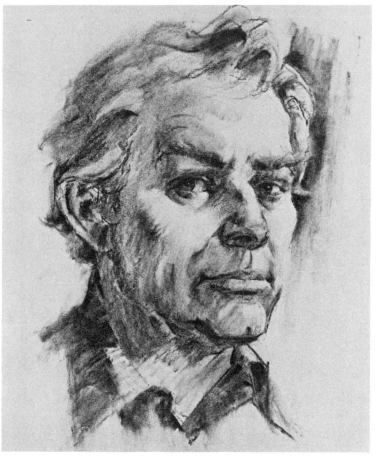

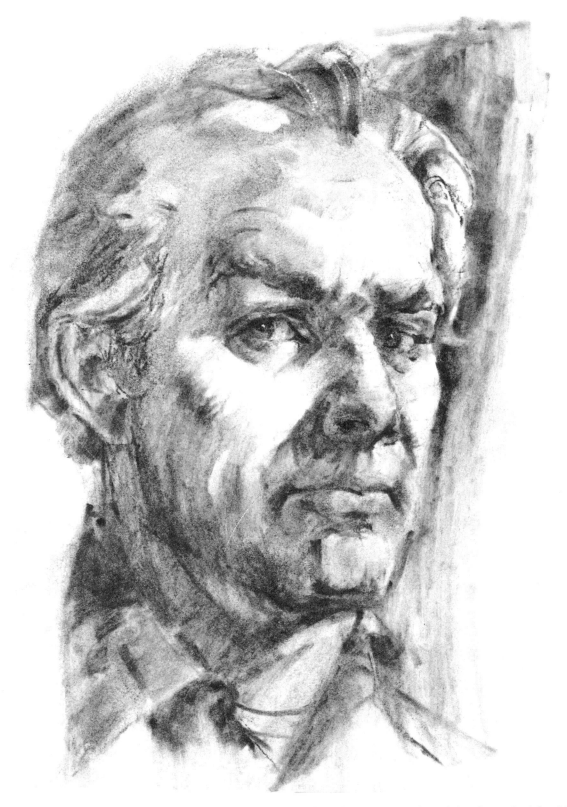

Step 7. The artist goes back over the tonal areas with additional strokes and blends them with his finger, gradually darkening the shadows until there's a powerful contrast between the dark and light sides of the forms. In Step 6, you saw sharp lines surrounding many of the features; now these lines are softly blended so that they fuse with the surrounding shadows. There are almost no lines in the final drawing, except for a few sharp touches of the charcoal stick within the eyes and ear, inside the nostrils, and between the lips. The kneaded eraser brightens the forehead, cheeks, nose, and chin, "draws" some wrinkles in the cheek on the left, and lifts some patches of light out of the hair. The corner of the razor blade scratches some white lines into the hair and brightens the highlights on the pupils.

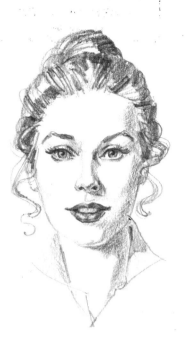

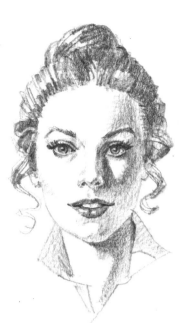

Three-quarter Lighting. Learn to identify the direction of the light before you start to draw a portrait. Here, the light comes from the left side, over your shoulder. Most of the face is brightly lit, but there are narrow strips of shadow on the right sides of all the forms. This is a flattering light for most sitters.

Side Lighting. The light no longer comes over your left shoulder, but seems to be at the sitter's side, placing more of the face in shadow. Most of the right side is dark, with a small, bright triangle on the cheek that curves forward to catch the light. The protruding nose casts a dark shadow on its right side. The eye sockets are also in deeper shadow.

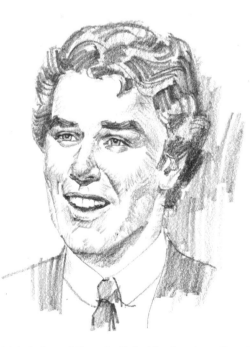

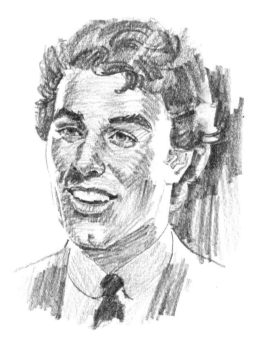

Frontal Lighting. When the light hits the sitter directly in the middle of his face, there are big patches of light in the centers of all the forms, with shadows around the edges. Thus, the forehead is bright in the middle and shadowy at the sides. So are the nose, cheeks, and chin. The chin and jaw cast a strong shadow down the center of the neck.

Rim Lighting. This light source is behind the sitter, and most of his face is in shadow. But the light creeps around the edges (or the rims) of the face. Although the front of the face is in darkness, there's a distinct contrast between the shadows and the halftones that define the features. Shadows are rarely pitch-black; they're filled with subtle light.